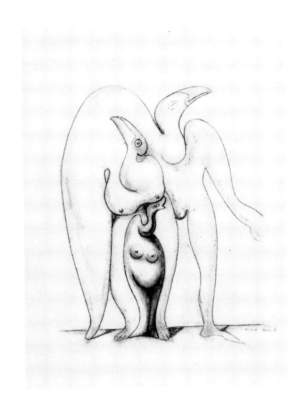

max ernst

Great Modern Masters

Ernst

General Editor: José María Faerna

Translated from the Spanish by Alberto Curotto

CAMEO/ABRAMS

HARRY N. ABRAMS, INC., PUBLISHERS

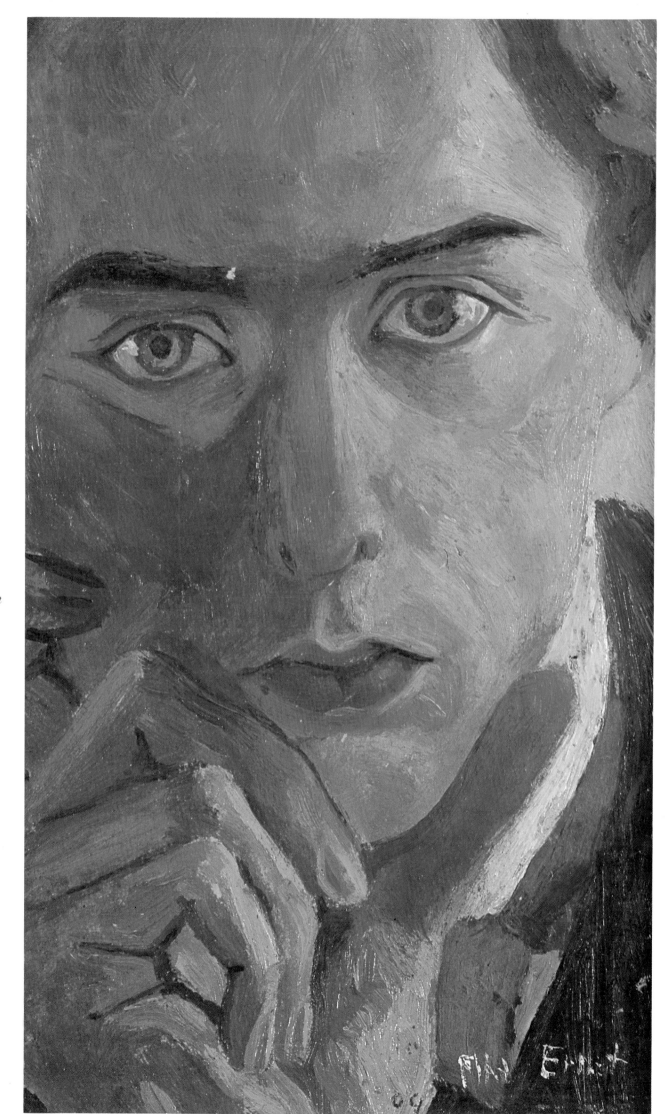

Self-Portrait,
*1909. Oil on
paperboard,
7⅛ × 4¾"
(18 × 12 cm).
Collection Stadt
Brühl*

Max Ernst's Surrealist Coherence

Surrealism was established initially as a literary movement, launched by a group of poets whose aesthetic considerations focused exclusively on the written language. Today with the images of Surrealist painting and cinema firmly ingrained in our cultural consciousness, it is important to remember that for quite some time, the prevailing issue debated within the movement was whether or not the literary aesthetics could be translated to the visual arts. Many early Surrealists in fact, such as Pierre Naville, ruled out even the possibility. If there is one single artist responsible for the development of Surrealist painting, that is Max Ernst (1891–1976). Ernst's association with Surrealism can be said, paradoxically, to date from prior to its beginnings; indeed, he played an influential role even on the evolution of the theoretical works of the founder of Surrealism himself, André Breton.

Poetic Objectivity

The remarkably radical nature of Ernst's artistic contribution was already evident by the second decade of the century. During his Dadaist beginnings, he launched a head-on attack against the traditional notion of individual talent or "the fanciful myth of creativity." The goal of the new course was, in the artist's own words, "the attainment of poetic objectivity," one that would be achieved by "eliminating intelligence, taste and conscious volition from the process of origination of the work of art." Yet despite the criticisms against such venerable concepts of Western civilization, Ernst, like Marcel Duchamp, did not choose to renounce all artistic activity. As a consequence, Ernst soon became attuned to the group of French intellectuals who, under the leadership of André Breton, were attempting to transcend the anarchy of the Dadaists and find new ways to organize their own achievements in a theoretically coherent manner.

Emancipation through Surrealism

The extent of Ernst's affinity with the French intellectual circle was far-reaching: even as a youth, he had developed a profound interest in Freud's discoveries and, like Breton, Ernst was intrigued by pictures painted by mental patients. He saw in these pictures evidence of the countless possibilities afforded to visual expression once it is freed from the conventional reason. Hence, the discovery of Ernst's earliest collages stirred a great commotion among the first Surrealists, even before they chose to be known by that label. Surrealism posited the necessity to transgress the narrow confines within which civilized human life unfolds. The Surrealists believed civilization drastically curtailed all the supernatural and fantastic aspects of the individual spirit. The unconscious, the Surrealists contended, could afford just such opportunity of escaping those constraints, namely through the release of repressed urges. Their own experimentation with psychotropic substances and hypnosis opened the doors to a new, endlessly suggestive universe. The union of this newly discovered realm—until then relegated to the unconscious—with the world of wakeful experiences would give rise to a new, fuller reality, a "super-reality," as

This peculiar self-portrait was used in an invitation to an exhibition of works by Ernst held in Paris in 1935.

The Harmonious Bassoon, *1922. One of the collages that Ernst created to illustrate Paul Eluard's* Les malheurs immortels.

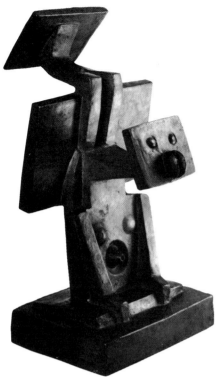

A Solicitous Friend, *1944. Ernst's artistic activity also included sculpture, which he approached with a distinctly Surrealist object-focused sensibility.*

The Conduct of the Leaves, 1925. Conduct *represents a typical example of* frottage, *one of the automatic techniques originated by Ernst.*

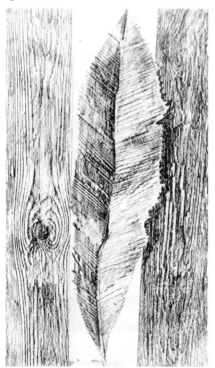

it were; hence the name "Surrealism" (*surréalisme*, in French) coined by Guillaume Apollinaire for the emerging movement. Firmly ensconced in this belief, the Surrealists set out in search of mechanisms that would enable them to free the creative energy hidden in the depths of the human mind. They then triumphantly discovered automatic writing and, with it, the poetically fraught images that spring from applying randomness to the process of literary creation. In his manifesto of 1924, Breton himself summarized these Surrealist experiments as "pure psychic automatism, by which it is intended to express verbally, in writing or by other means, the real process of thought. It is thought's dictation, all exercise of reason and every aesthetic or moral preoccupation being absent."

New Techniques

Ernst's most notable talent lay in his ability to develop new expressive techniques that allowed him to translate to the visual arts the discoveries of the Surrealist investigation which, in principle, seemed to be limited to the literary arts. His earliest collages already constituted the germ of what later became one of the foundations of Surrealist iconography. Unlike traditional art, Surrealist imagery does not rely on the mechanical imitation of the sensible world; instead it is grounded in the creation of worlds that are as divergent from the conscious reality as possible. One of the products of Ernst's investigations was *frottage*, a technique based on randomness that enabled him to introduce to the visual realm a mechanism equivalent to the automatic writing of Surrealist literature. The purpose of Ernst's quest was to find new means of expression that would conform to the human model posited by Surrealism. In order to open up for the artist and the viewer alike a virtually boundless field of vision, he strove to produce a new type of "painting that would take giant steps to distance itself from Renoir's apple trees, Manet's asparagus, Derain's little chocolate ladies, or even the Cubist pack of cigarettes."

Appearances at a Juncture

In the debate concerning the reliability of physical appearances, Ernst succeeded in invalidating the supreme power of scientific thought which had presided over Western civilization since the Enlightenment. Through his friendship with the German physicist Werner Heisenberg, the father of the uncertainty principle of quantum mechanics, Ernst was able to vindicate his own belief in the sheer indeterminacy dominating the cognitive process. His use of techniques like collage, *frottage*, and *grattage* reflected just this criticism of appearances, as they insinuate a different type of reality, a richer reality, one that is heavily charged with a sense of mystery, such as those typically Ernstian leaves sprouting from the veins of wood, or those spectral beings that rise unexpectedly from the pits in the texture of the canvas. Unlike other Surrealist painters such as Salvador Dalí who, having come upon the right method to elicit surprise, proceeded to wear it *ad nauseam*, Max Ernst consistently displayed a strong inquisitive tension and a fondness for risk-taking that enabled him to continue—well into his fifties—to discover and experiment with new expressive techniques, such as *dripping*, and to rise as a beacon for several generations of post-war artists, from the Abstract Expressionists to Pop artists.

Max Ernst / 1891–1976

Max Ernst was born in the German town of Bruhl, near Cologne. His father, Philipp Ernst, was a teacher for the hearing-impaired and an amateur painter. In 1909, after graduating from high school, the young Ernst moved to Bonn, where he enrolled at the local university and majored in philosophy. Independently, he pursued the study of art history, and began to familiarize himself with works of art created by mental patients. He made it a point to carefully avoid "any formal lesson or course of studies that may readily degenerate into a mere tool to earn one's daily livelihood." Ernst's earliest paintings—dating from precisely this period—are works of Expressionistic derivation, which betray the influence of the artist's friendship with August Macke, a member of the group *Der Blaue Reiter* (The Blue Rider). The celebrated Sonderbund show of 1912 in Cologne afforded the young Ernst the opportunity to see firsthand works by Paul Cézanne, Vincent van Gogh, Paul Gauguin, Edvard Munch, and Pablo Picasso, and thus served as the catalyst for his decision to devote himself to painting.

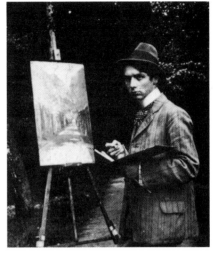

Above is an early image of Max Ernst, photographed in his native Bruhl in 1909. At the time, the artist was making his first forays into Expressionism.

Dada in Zurich and Cologne

In 1913, Ernst's work was shown at the first Fall Salon organized in Berlin by the review *Der Sturm*. His paintings were exhibited alongside those of Paul Klee, Marc Chagall, Robert Delaunay, and Hans Arp; Arp later became one of the artist's closest friends. As it did for many of his generation, World War I proved to be a defining experience for Ernst. Drafted as an artilleryman, the artist perceived his civilization as absurd for setting off the bloodbath, and once referred to the war as "the dirtiest of tricks." This view conformed to that of the group of intellectuals and artists who, in 1916, convened at the Cabaret Voltaire in Zurich and launched Dadaism. The following year, Ernst participated in the group's second exhibition and, in 1919, he and J. T. Baargeld established a "subsidiary" of Dada in Cologne which, after enlisting Arp, would change its name to "Zentrale W/3 Stupidia."

Max Ernst (far right) in Tyrol, in 1921, in the company of Tristan Tzara, Maya Chruseces, Lou Ernst, and André Breton, three years before the formal establishment of Surrealism.

The Dawn of Surrealism

Together, Ernst, Baargeld, and Arp, produced a series of collages known by the name of *Fatagaga*s, which they unsuccessfully tried to exhibit at the show of the Cologne Artists' Union. When the committee of the association refused to grant admission to the *Fatagagas* for being "undesirable," Baargeld and Ernst showed their works in a back room of the Winter Beerhouse. The viewers, after walking past the urinals, were confronted with works such as the *Fluidoskeptryk*—a fish tank filled with a blood-red liquid, holding a lock of hair, a wooden hand, and an alarm clock—which, the very day of the opening, was smashed to pieces by a little girl who, dressed in a first communion robe, had previously recited some obscene verses. The confusion created by the show is reflected in the motivation cited by the police in their closure order: a collage, derived from an engraving of *Adam and Eve* by Albrecht Dürer, was considered pornographic; however, when its source became apparent, the ban was lifted. It was precisely Ernst's collages that gained him access to the world of the Parisian avant-garde. In 1921, Breton—who, a few years later, would become the

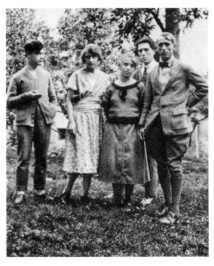

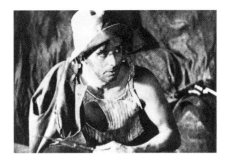

Like other Surrealists, Max Ernst appeared in Luis Buñuel's The Golden Age, *quite possibly the pinnacle film inspired by the movement.*

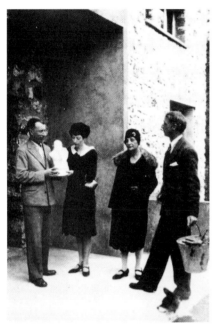

Max Ernst photographed with Hans Arp, in Meudon, in 1928. Earlier during the years of World War I, the Swiss artist, Arp, was an active member of the Dadaist group in Zurich.

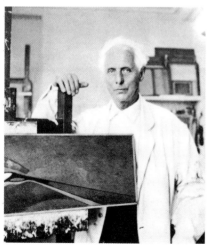

A photograph of the artist in his own studio, presumably taken in the 1950s after his permanent return to Europe.

foremost apostle of Surrealism—invited the German artist to exhibit his collages in the French capital. This occurrence, three full years before the first manifesto of Surrealism was issued, marked the beginning of Ernst's association with the movement. His Dadaist phase over, the artist's earliest Surrealistic works bespeak the influence of Giorgio de Chirico's metaphysical painting.

The War Years

The two following decades of Ernst's career were marked by intense probing and research: the painter, attempting to reproduce in the visual arts the Surrealist literary mechanism of automatic writing, would develop techniques such as *frottage*—the first examples of which are collected in a series titled *Natural History*—and *grattage*. It was along these lines that he completed in 1929 the first of his collage-novels, *The Woman with 100 Heads*, followed five years later by *One Week of Goodness, or The Seven Deadly Elements*. Subsequently, he would also embrace *decalcomania*, a technique pioneered by Óscar Domínguez. In 1938, together with Paul Eluard and Man Ray, he published *The Man Who Lost His Own Skeleton*, a vitriolic denunciation of Breton and his compatriots, which concluded Ernst's definitive withdrawal from the Surrealist group. In his works from the late 1930s, the artist utilized his recent technical discoveries to express a mostly bitter view of the times. The threat of fascism is patently present in several paintings, such as *Barbarians Marching to the West* or *The Angel of Hearth and Home*. Ernst, whose name had been blacklisted by the Nazis in 1933, had to endure further humiliation and suffering when, at the first outbreak of World War II, he was interned in a number of French concentration camps on account of his German nationality. In 1941, after a long series of reversals and other vicissitudes—among which, the providential intervention of a police inspector at the French-Spanish border post of Canfranc who, admiring the paintings found in the artist's luggage, allowed him to escape the German army—Ernst eventually found his way to the United States.

Ernst and the Art of the Post-War Period

The physical distance notwithstanding, the war continued to haunt the exiled artist. In his earliest American works, Ernst resorted to the technique of *decalcomania* to depict the desolate and death-strewn landscape into which Europe had fallen in the aftermath of the conflict. The hardships of the exile—financially all of his shows were absolute failures—did not in any way lessen his investigative drive. In 1942, he began painting *Young Man Intrigued by the Flight of a Non-Euclidean Fly:* as a work that employed the *dripping* technique, it would prove highly seminal in the post-war years for the newest generation of American artists, including among others Jackson Pollock. Through the forties, Ernst's paintings became increasingly abstract, as their earlier organic exuberance gradually gave way to geometric compositions dominated by flat colors. After returning to France, where he permanently settled in 1952, the artist resurrected the most typical techniques of his earlier phase, collage and *frottage*. In 1954, his work officially received universal recognition in the form of the Grand Prix for Painting at the Venice Biennale. From that moment until the time of his death, in 1976, a long succession of retrospective exhibitions celebrated his oeuvre and established Ernst's role as one of modern art's fundamental innovators.

Plates

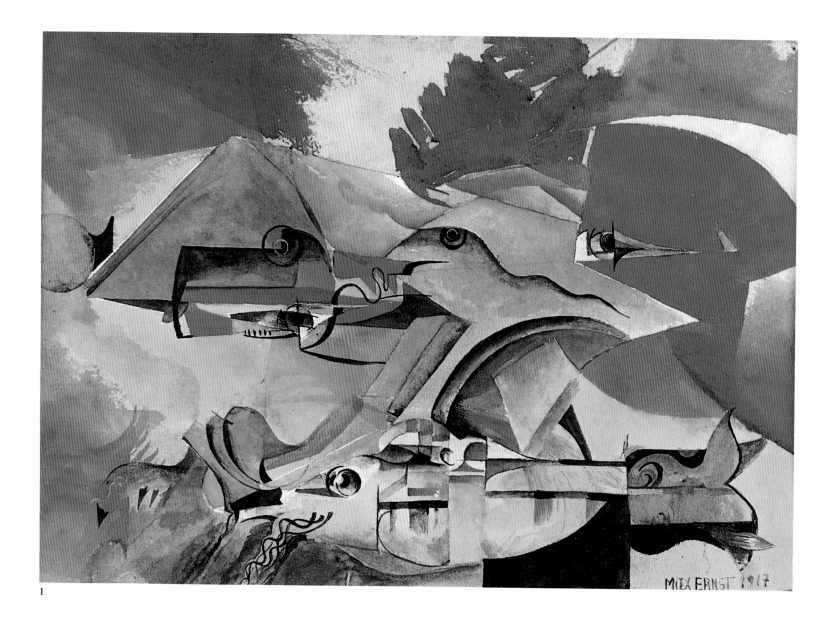

1

Beginnings

From the very outset of his artistic career, Ernst displayed the characteristic independence that would distinguish him for the rest of his life. His dismissal of academic art and his avoidance of any formal instruction allowed him an uncommon lack of prejudices toward the acceptance of new suggestions, to the extent that his earliest works constitute a rather lucid mirror of the prolific artistic scene of the 1910s. His paintings reveal an admiration of van Gogh, Cézanne, and Munch. They also bespeak his close association with the German Expressionists, specifically with the members of *Der Blaue Reiter* (The Blue Rider), in whose group shows he took part as early as 1913. These paintings, though, at the same time convey echoes of the Futurist æsthetics and of the Cubist artistic idiom. Another very important influence reflected in these works was that of Marc Chagall's fantastic universe, with its quirky compositions and floating figures. Yet, the cheerful ingenuousness and popular inspiration of the Russian-Jewish artist is quite alien to the spirit underlying Ernst's production which, instead, exudes a bitterness strongly reminiscent of the tense images painted by his countryman Ludwig Meidner.

1 Fish Fight, *1917. On the whole, of the various influences that affected Ernst's early development as an artist, Cubism is not the most obvious. However, the teachings of the Cubist experience are quite apparent in a series of works, such as the present one, that he painted around 1917.*

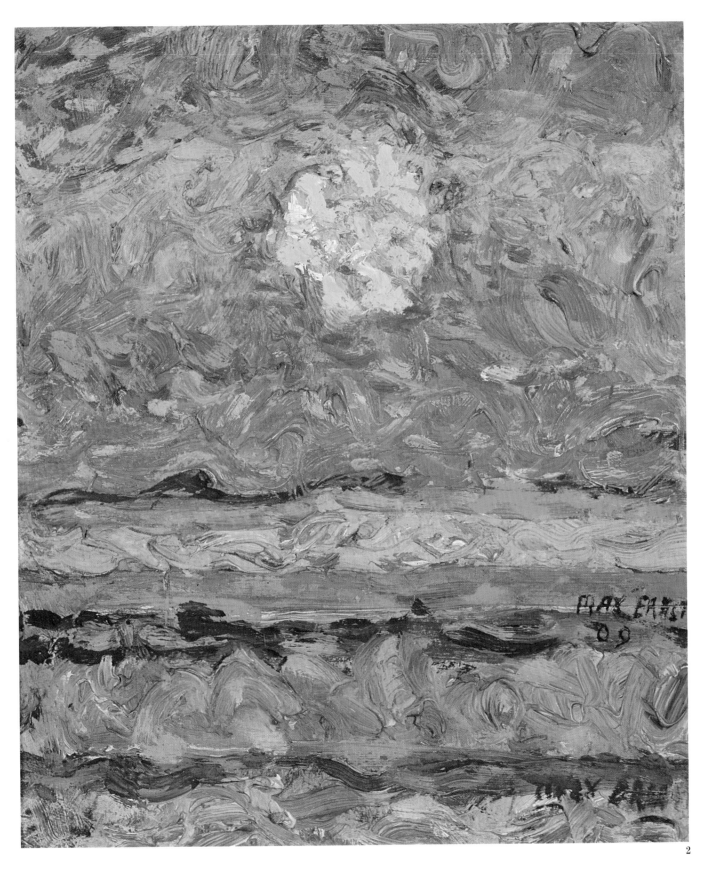

2

2 Landscape with Sun, *1909. One of the earliest known works by
the German artist. The thick, heavy brushwork and the chromatic
intensity of this picture attest to Ernst's profound fascination
with the paintings of van Gogh, and they may even point to his
early knowledge of the works of the first generation of German
Expressionists, the group* Die Brücke *(The Bridge).*

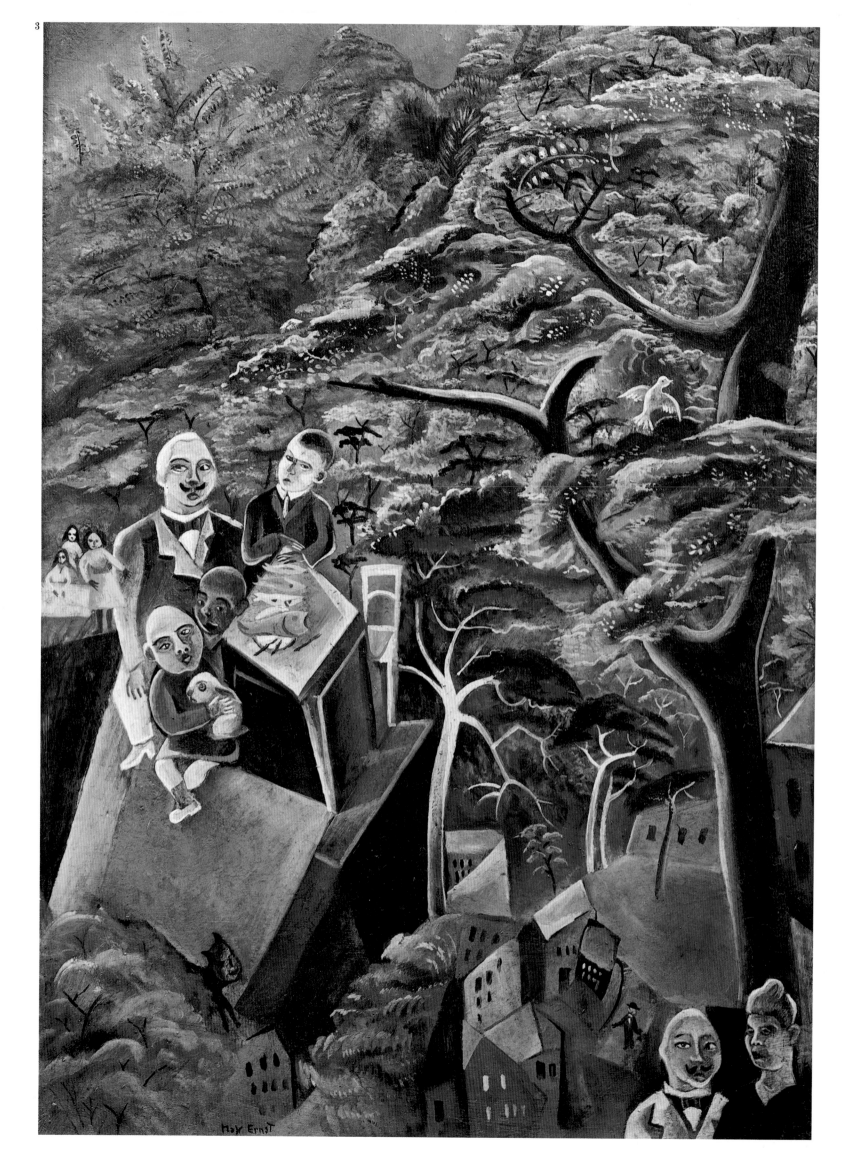

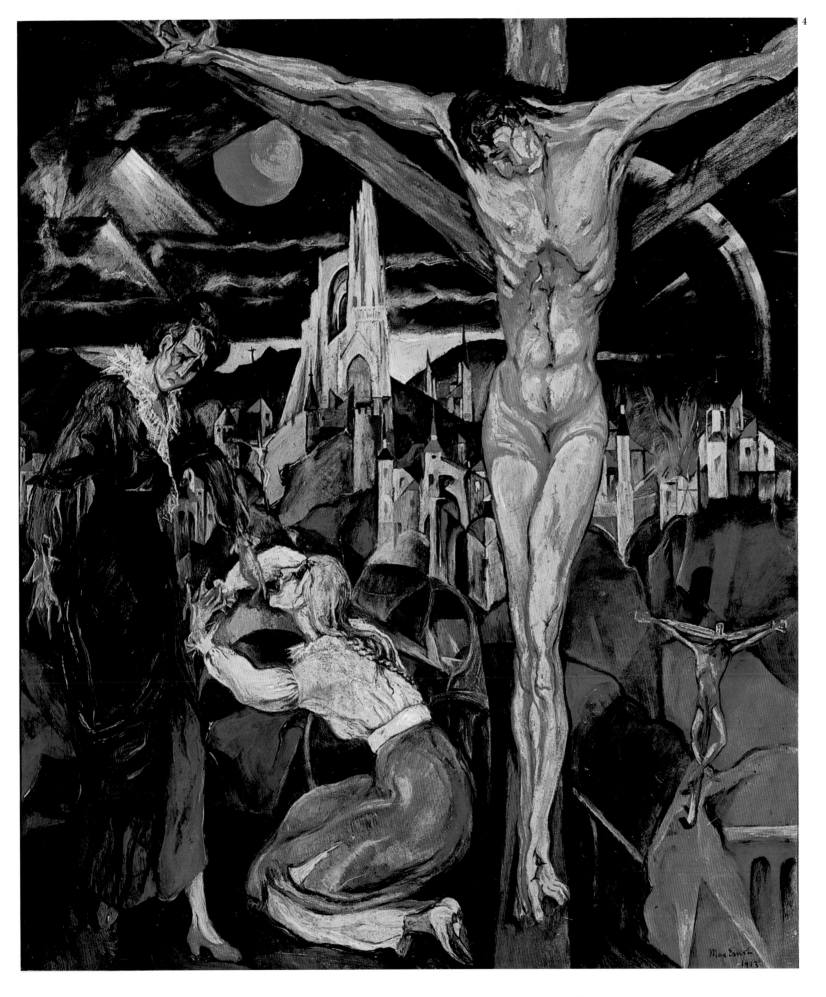

3 Immortality, *1913–14. The spiritual bias of the title, as well as the superimposition of disparate elements drawn in different scales and from different angles are reminiscent of Marc Chagall's imagery. However, the figures' disturbing countenances and their placement, floating above a city overrun by vegetation, point more toward the works of the German Expressionists from the 1910s.*

4 Crucifixion, *1913. In this painting, Ernst combines two quite distinct influences: a landscape setting of Cubist derivation, and a scene in homage to Matthias Grünewald, the sixteenth-century German painter who had become in the twentieth century one of the most revered heroes of Central-European Expressionism.*

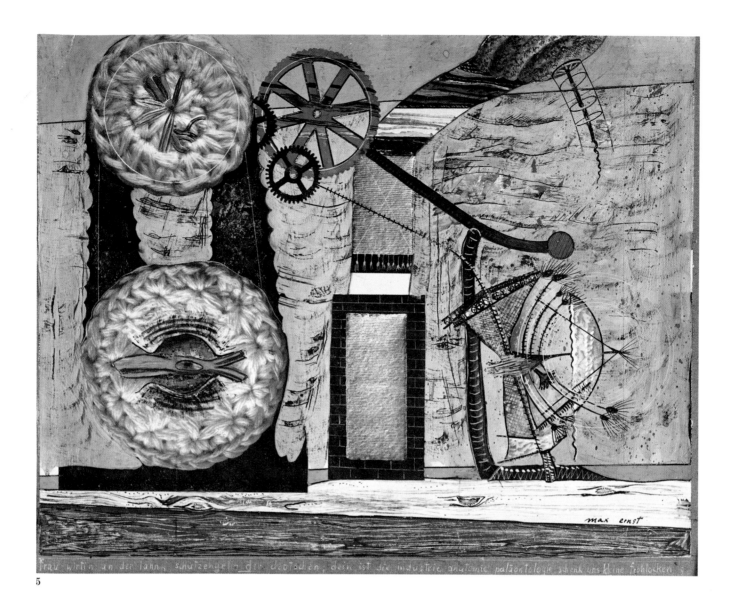

5

The Dadaist Revolution

After its creation in Zurich in 1916, in the midst of World War I, Dada soon crossed the neutral borders of Switzerland and swiftly extended to the rest of Europe. With uncompromising radicalism, the Dadaists, who included intellectuals and artists from both sides of the war, launched their attack against every manifestation of the bourgeois establishment: bourgeois customs that intellectually castrate the individual, depriving one of his or her most authentic freedom; bourgeois "rationality" that had justified the horror of World War I; and above all bourgeois art. Their ideas materialized in spectacular, often violent feats, such as the one that Ernst himself staged in 1920 on the occasion of the exhibition at the Winter Beerhouse in Cologne. The criticism of the most sacred values of Western civilization, like beauty and the creative genius, led the artist to develop new techniques and mediums, such as collage and photomontage. One of the direct products of this quest were the *Fatagagas*—from "FAbrication de TAbleaux GAranties GAzométriques" (Manufacture of Pictures Gasometric Warranties)—which Ernst realized in collaboration with Hans Arp and J. T. Baargeld.

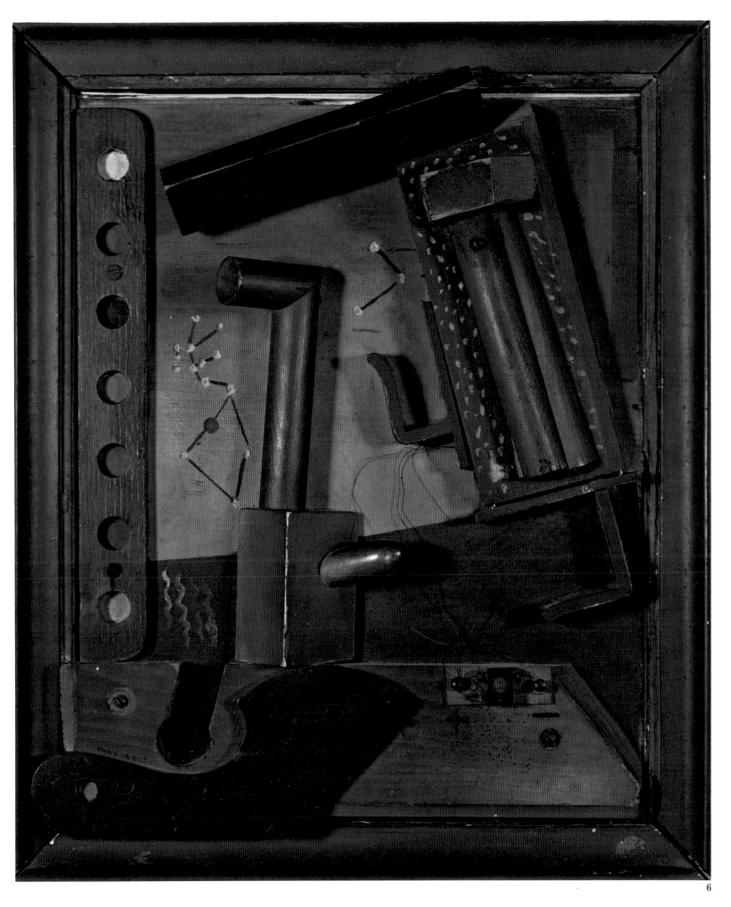

6 Fruit of a Long Experience, *1919. This Dadaist collage is closely reminiscent of Kurt Schwitters's* Merz *works. The random confluence of disparate objects amounts to a frontal attack on the traditional notion of creativity: the artist's intervention is kept to a minimum and is stripped entirely of any vestige of technical expertise, a fact ironically underscored by the title itself.*

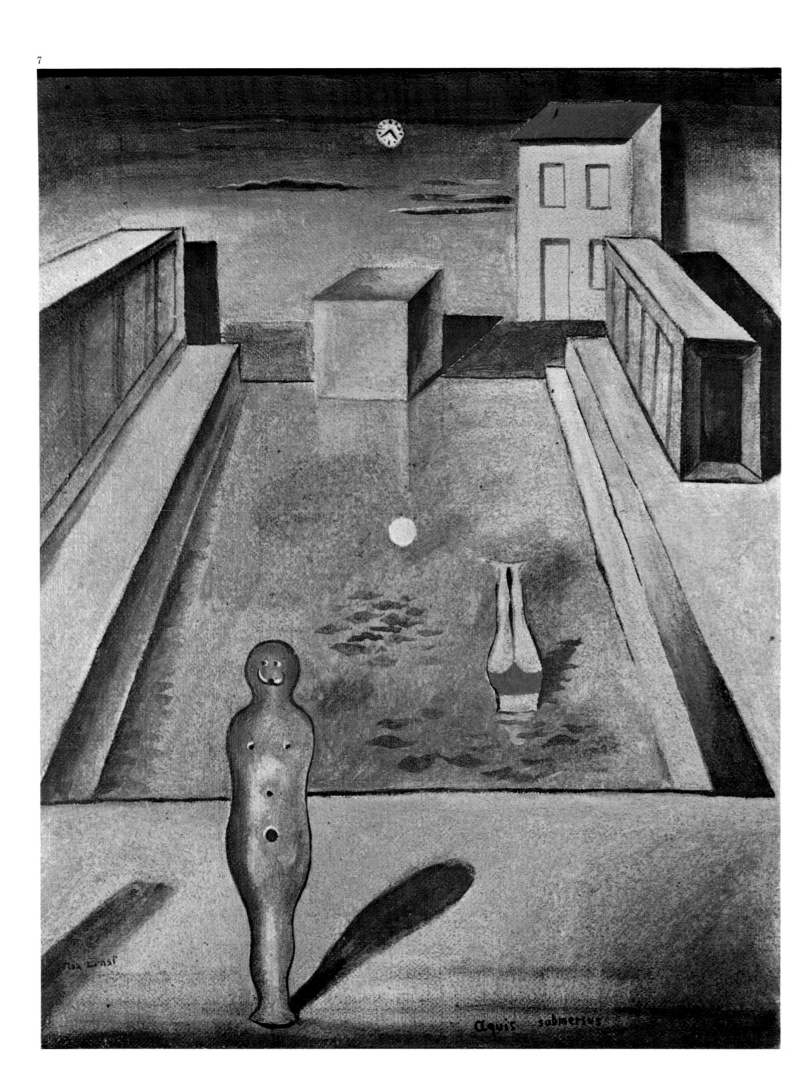

7 Aquis Submersus, *1919. This painting reflects the unmistakable impression produced on Ernst by the work of Giorgio de Chirico, which he had discovered on the pages of the review* Valori plastici. *There is, nonetheless, a certain ironic quality, such as the pitiful immobility of the half-submerged figure alluded to in the title, or the moon with a clock face, that is entirely lacking in the imagery of the metaphysical painter.*

8 The Great Orthochromatic Wheel Making Customized Love, *1919–20. Ernst explored in this painting the popular Dada theme of machinery endowed with mysterious erotic workings. The most widely known examples of this genre were created by Francis Picabia and Marcel Duchamp.*

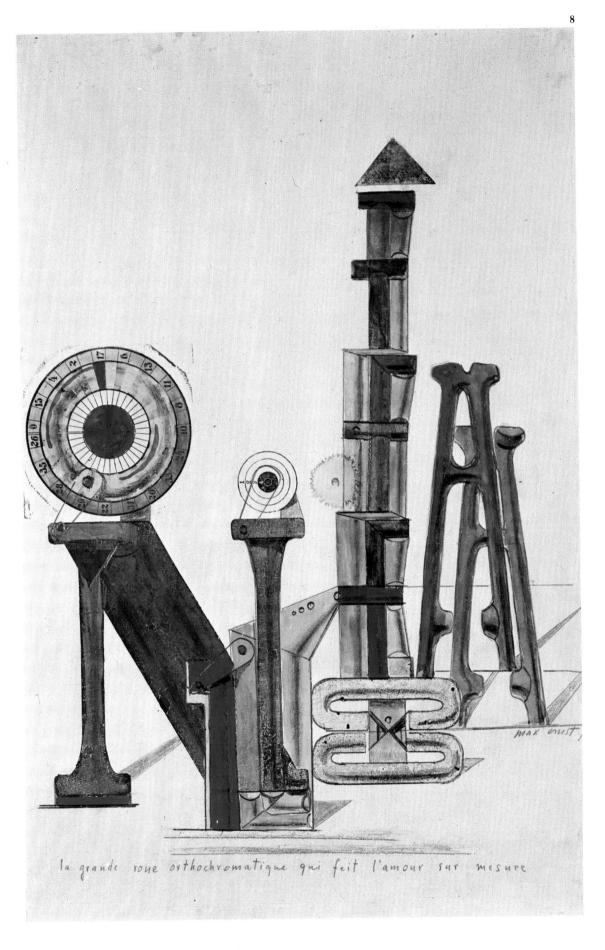

la grande roue orthochromatique qui fait l'amour sur mesure

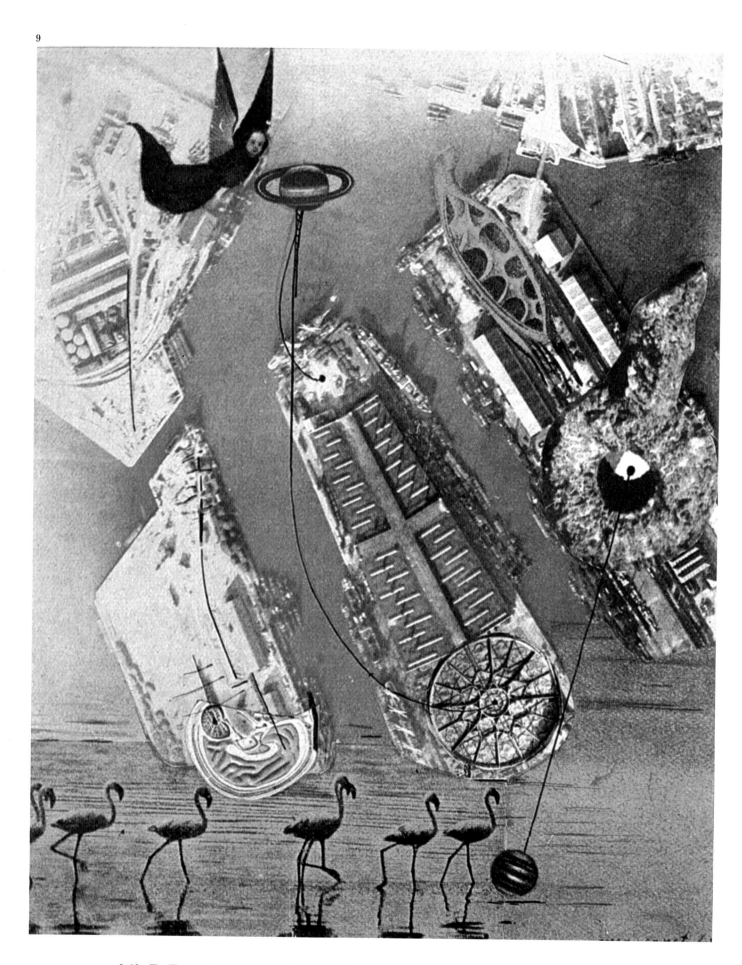

9

9, 10 The Flamingos, *1920; Self-Portrait, 1920. Ernst carried on the Dadaist tradition of the photomontage in these two examples of Fatagaga. The shocking power of these images springs from the association of distant and divergent realms, which would later become one of the foundations of the Surrealist aesthetics.*

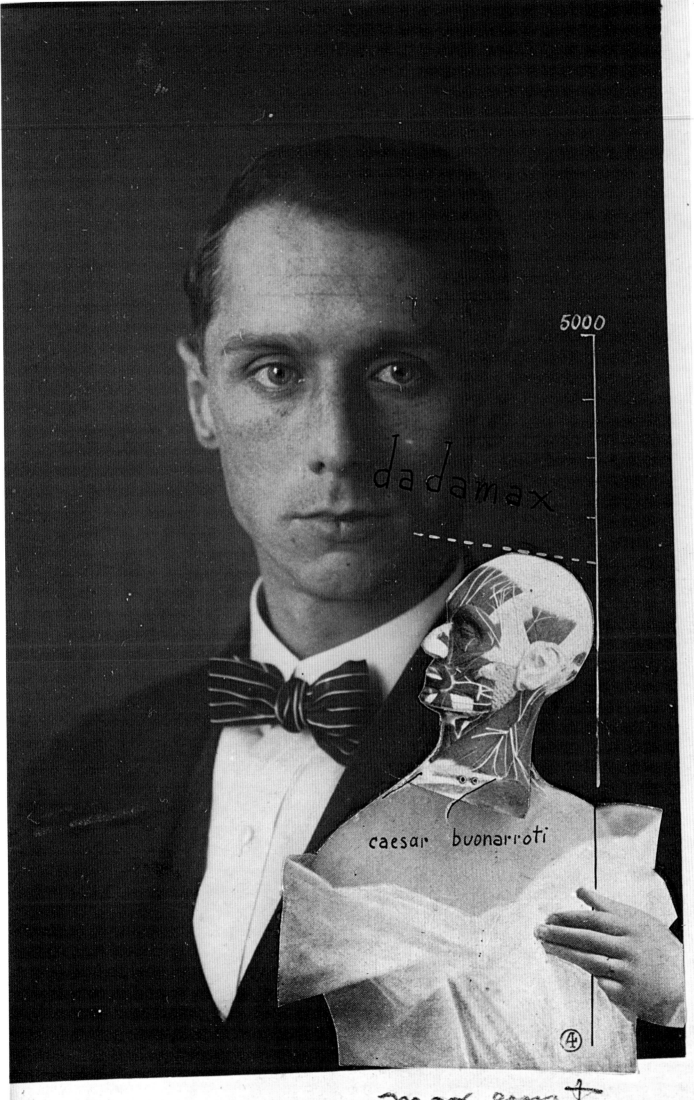

das schlafzimmer des meisters es lohnt sich darin ein

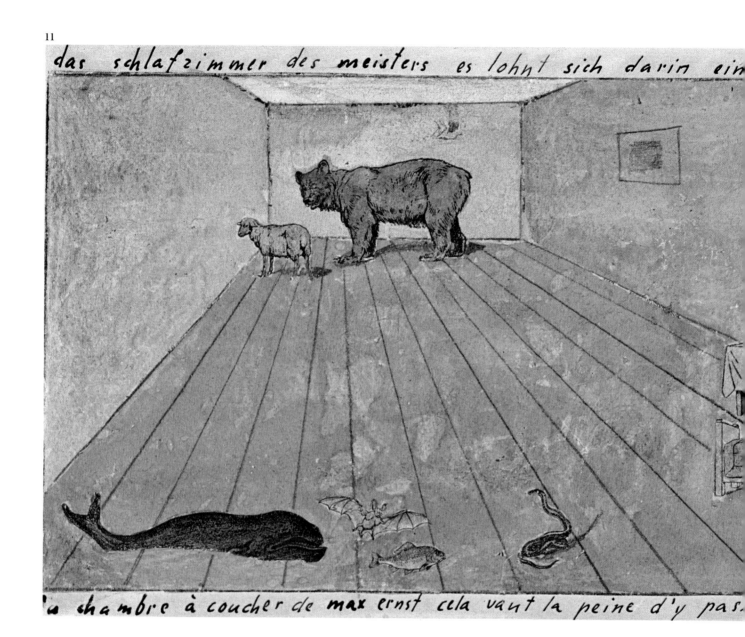

la chambre à coucher de max ernst cela vaut la peine d'y pas.

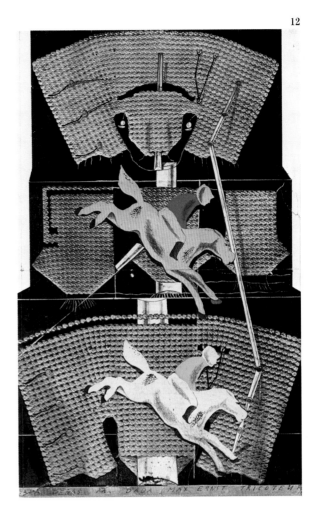

11 The Master's Bedroom It's Worth Spending a Night There, *1919. A wonderful example of the disturbing effects that Ernst was able to achieve by means of the "estrangement" technique: in spite of the title's unspoken invitation, the viewer is induced to question the wisdom of spending the night in an enclosure that equivocally harbors out-of-scale creatures such as a bear, a bat, and a whale. The sense of unreality is ominously heightened by the extreme rendering of perspective and by the precarious placement of the furniture.*

12 Dada-Degas, *c. 1920. The Dadaists' abhorrence of museum art targets here the Impressionist painter Edgar Degas, whose famous depictions of horses and racecourses are ridiculed by the pair of cut-out childlike horses. The sarcastic nature of this work is underscored by the epithet of "tricoteur" (knitter) that Ernst awards himself in the inscription at the foot of the picture.*

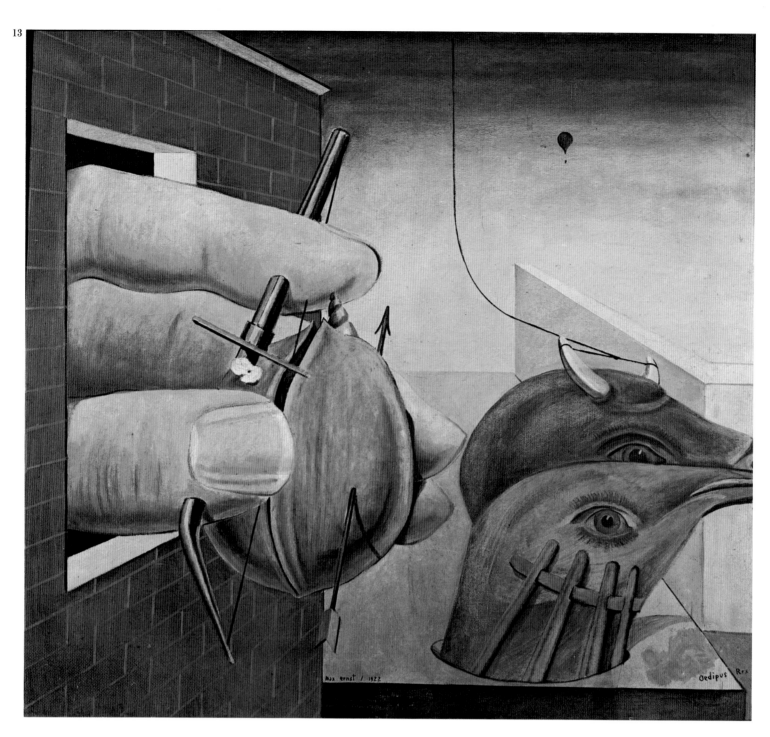

Surrealism

For the protagonists of French Dadaism, by their own admission, the discovery in 1921 of Ernst's collages had the power of a genuine revelation. By that time, a group of poets, headed by André Breton, had been meeting regularly in search for an alternative to the dead end to which they had been led by the nihilist tendencies of Dada. In the catalog of the exhibition that introduced the Parisian public to Ernst's work, Breton himself praised the painter's ability to combine two distinct realms in a setting that is alien to both and, through their encounter, to successfully ignite a poetic "spark." With that, the French intellectual effectively revealed the underlying genius of the works created by the German artist. Interestingly enough, the same notion of beauty had been foreshadowed by Lautréamont in his celebrated utterance, "As beautiful as the haphazard encounter of a sewing machine and an umbrella on a dissecting table." In order to achieve just such effect, during the first half of the 1920s, Ernst abandoned the collage technique and practiced a naturalistic type of painting which readily betrays the mark of Giorgio de Chirico.

13 Oedipus Rex, *1922. Here Ernst applies the compositional principles of collage to painting. The disquieting power of this image is drawn from the unexpected scale of the sharply defined objects and by a number of cryptic references to the psychoanalytically crucial myth of Oedipus: the pierced walnut that looks like a half-open eye, and the vanishing orb of the hot-air balloon, presumably also an echo of a Symbolist painting by Odilon Redon.*

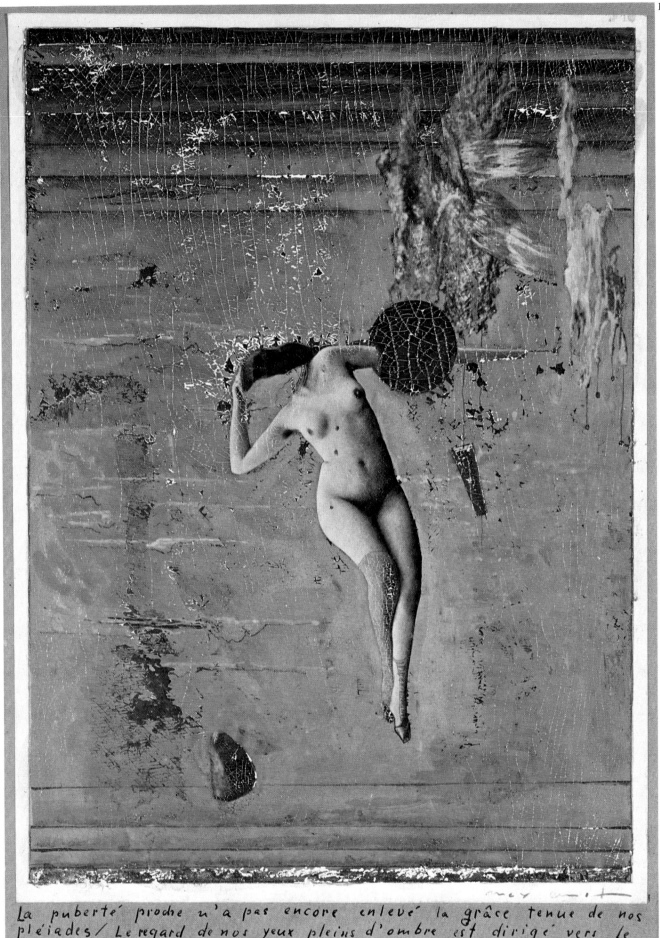

La puberté proche n'a pas encore enlevé la grâce tenue de nos pléiades / Le regard de nos yeux pleins d'ombre est dirigé vers le pavé qui va tomber / La gravitation des ondulations n'existe pas encore

14 The Pleiades, *1920. The expressive possibilities afforded by photomontage are clear in this work. Ernst, by freeing the nude figure—taken from an erotic postcard—from its original position, endows it with a weightlessness that enables the women to rise to the constellation of the Pleiades. The aerial voluptuousness of the body contrasts with the bulk of the swiftly falling rock.*

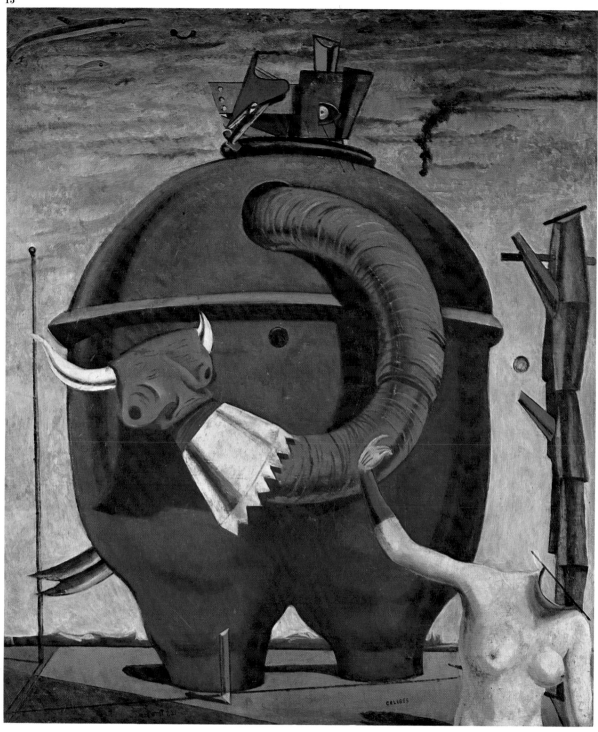

15 Celebes the Elephant, *1921. Building on the image of an African basket used for the storage of grains, Ernst spawned this monstrous animal. The meticulous brushwork, the spatial rendering, and the inclusion of an enigmatic mannequin betray the influence of Giorgio de Chirico's metaphysical painting.*

16 Ubu Imperator, *1924. In this painting, Ernst paid homage to Alfred Jarry—the father of the Theater of the Absurd and a forerunner of Surrealism—and to Jarry's most famous creation, Ubu. The grotesque tyrant of Jarry's play is shown here crammed into an armor that is reminiscent of the clay molds used to cast bronze statues. The scepter of his power, the sickle with which he severs his enemies' heads, rises by his side, partaking of the unlikely balance of his enormous figure.*

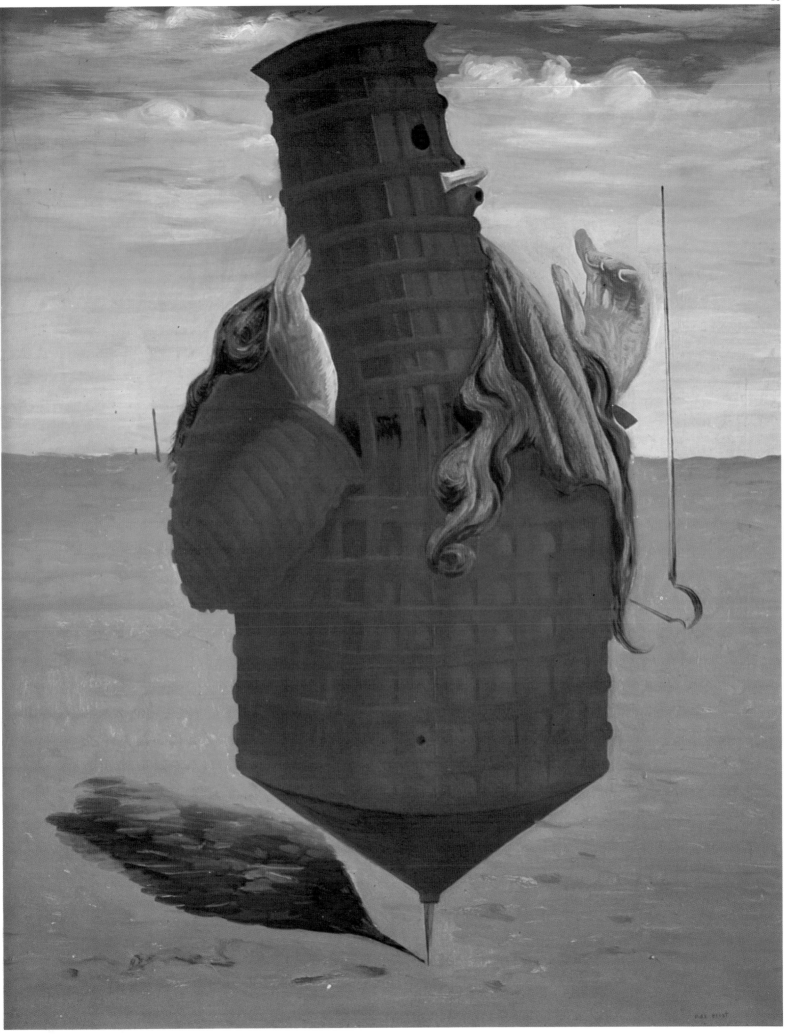

17 Pietà, or The Revolution by Night, *1923. Ernst's irreverent addition to the iconographic tradition of the Pietà provides further evidence of the strong influence that metaphysical painting had on his own work.*

18 Untitled, *1923. Soon after arriving in France, Ernst resided for a few months in the home of Paul Eluard, in Eaubonne, north of Paris. As a token of gratitude for his friend's hospitality, the artist decorated the doors and walls of the house with his personal interpretation of the illusionistic techniques of Pompeiian painting.*

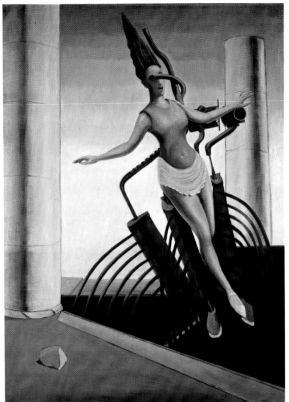

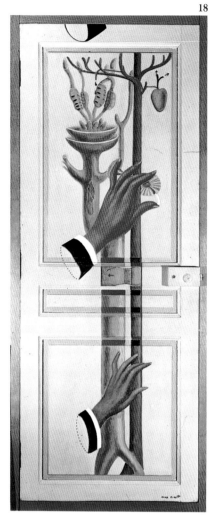

19 The Equivocal Women, *1923. Surrealist painters often portrayed women as mere erotic objects, treating them with considerable sadism. In this example, a sort of blind doll, whom some have seen as a representation of the goddess Fortuna, keeps her precarious balance on a bizarre artifact which Ernst had apparently copied from a nineteenth-century print depicting a wave-breaking machine.*

20 The Couple, *1923. This image challenges the viewer's perception: at first, one may think that the work is a collage, however the painter has painstakingly reproduced the lace's least details solely with his brush and oil paints.*

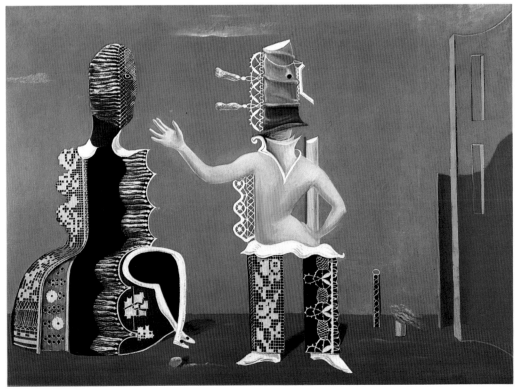

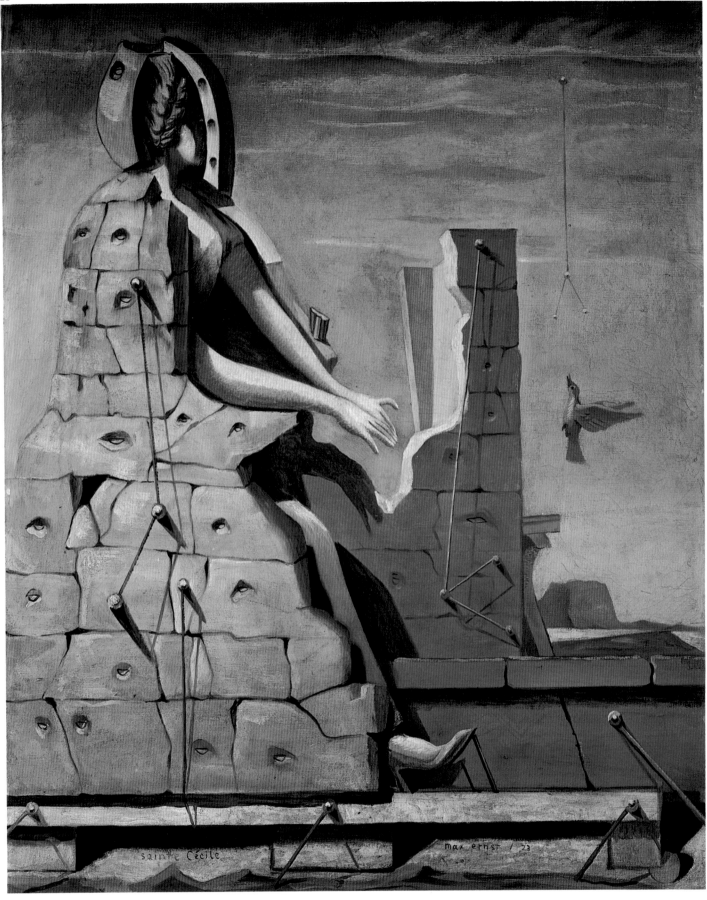

21 St. Cecilia (The Invisible Piano), *1923. Cecilia, the patron saint of music, hardly disengaged from the walls of her prison, seems to be playing an invisible piano. The meticulous brushwork, the highly contrasted chiaroscuro effects, and the allusion to incommunicability can all be traced to the influence of Giorgio de Chirico's paintings.*

22 At the First Clear Word, *1923. Hands figure prominently in many works by Ernst. Inasmuch as his father had been a teacher of sign-language for the hearing impaired, the theme of hands must be read as having great significance. In the present example, a hand is at the center of a complex allegory of the relations between the sexes: two of its fingers, suggestive of a woman's legs, precariously hold a sphere. If the sphere should fall, the insect attached to the opposite end of the string would be dragged along.*

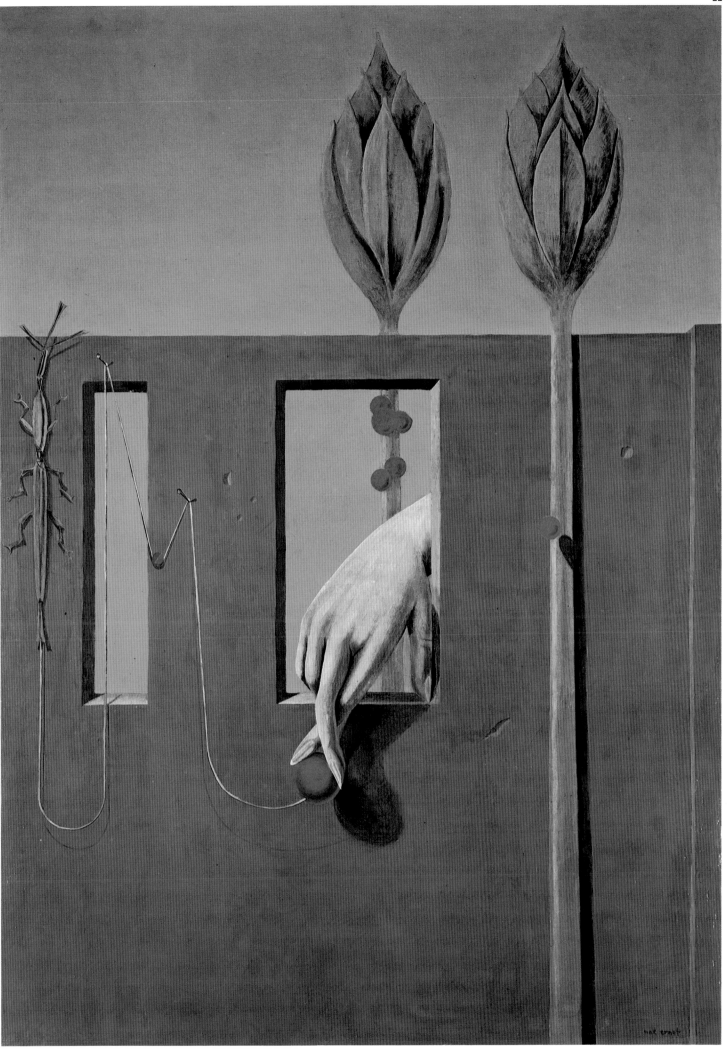

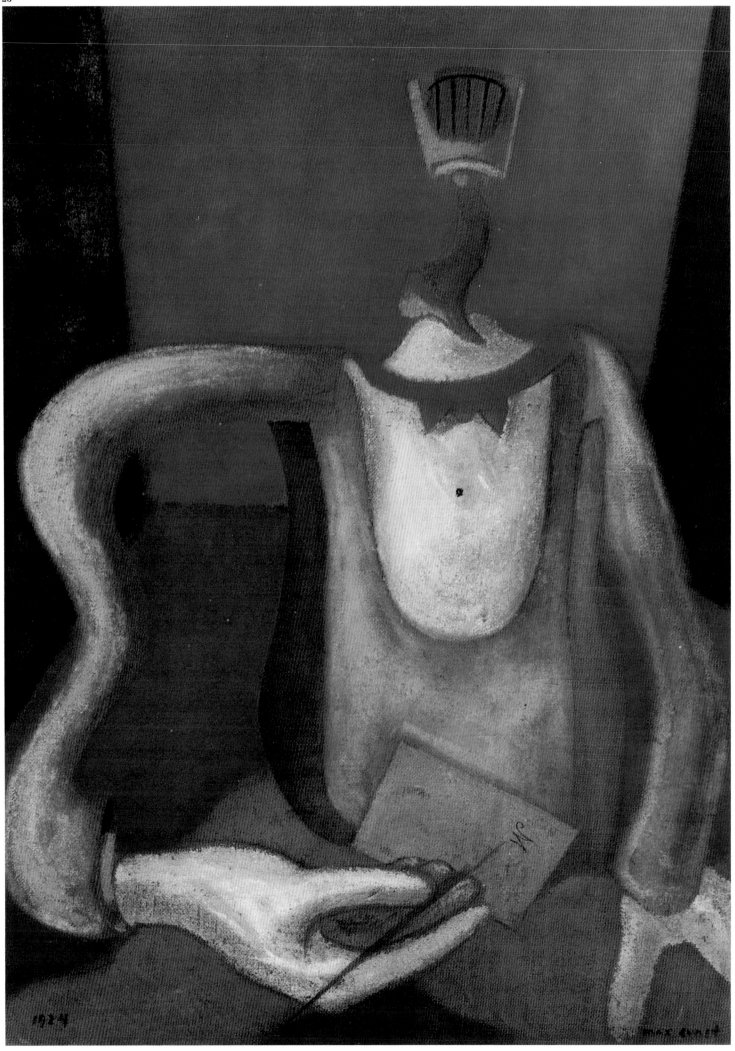

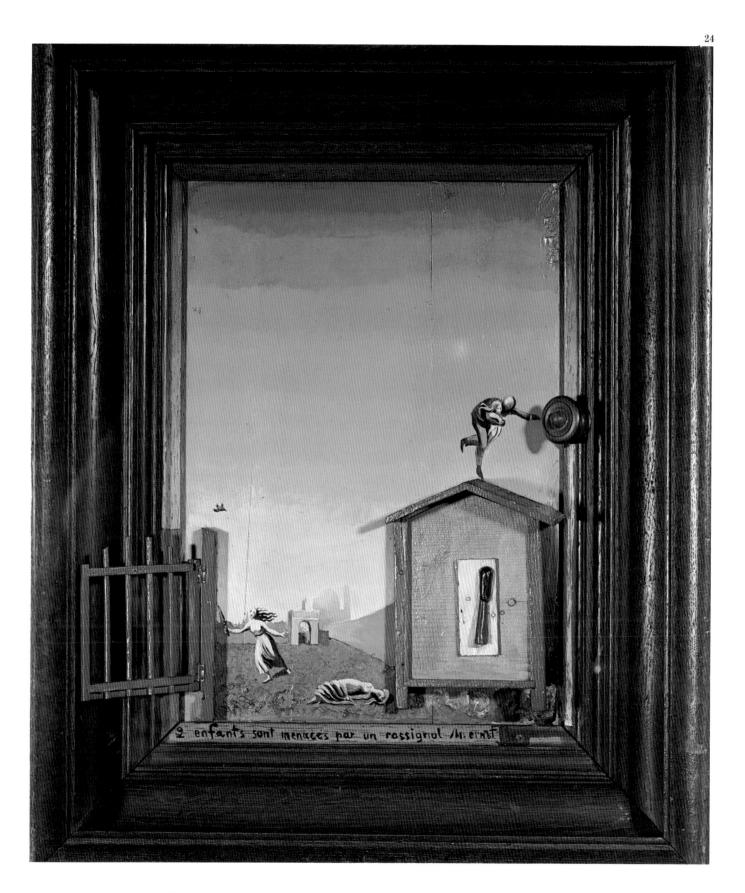

2 enfants sont menacés par un rossignol /M. ernst

23 M Portrait, or The Letter, *1924. Here again Ernst creates an autonomous hand that acts independently of the mind's authority: an unmistakable allusion to the mechanism of automatic writing which, by that time, had become the focus of the Surrealists' investigations.*

24 Two Children Are Threatened by a Nightingale, *1924. Ernst attempts here to generate in the viewer an unspeakable sense of uneasiness through the following elements: the sheer disproportion between the figures of the two desperate children and the nearly imperceptible source of the threat, a tiny nightingale; the mysterious figure that is taking flight; and the stubborn denial of the picture's two-dimensionality by means of the inclusion of three-dimensional objects.*

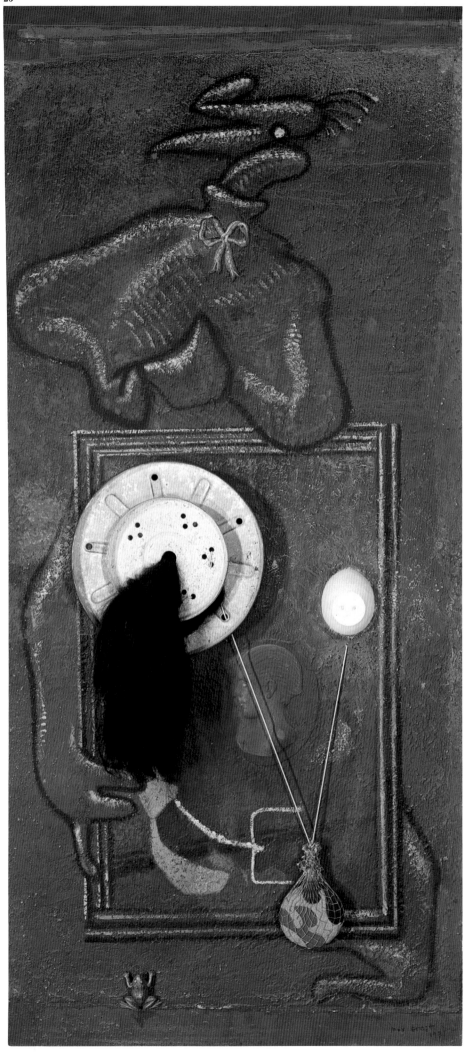

25 Loplop Introduces a Young Girl, *1931. The support for this depiction of Loplop is a board of plywood primed with plaster, used previously in Luis Buñuel's film* The Golden Age, *in which Ernst had appeared. Loplop, whose name was apparently taken from the verses of a popular Parisian street poet, is a trick bird-figure with whom the artist identified.*

26 The Blessed Virgin Chastises the Infant Jesus before Three Witnesses: A. B. (André Breton), P. E. (Paul Eluard) and the Artist, *1926. When the painting was first presented to the public at the 1926 Show of the Independent Artists in Cologne, it was considered blasphemous and elicited the formal condemnation of a group of Catholic artists. Two years later when the same work was again on display, the clergy of the German city succeeded in obtaining the closure of the exhibition. The scandal reached such proportions that the archbishop himself proceeded to publicly excommunicate the painter before the faithful gathered in the cathedral, among whom was the artist's own father.*

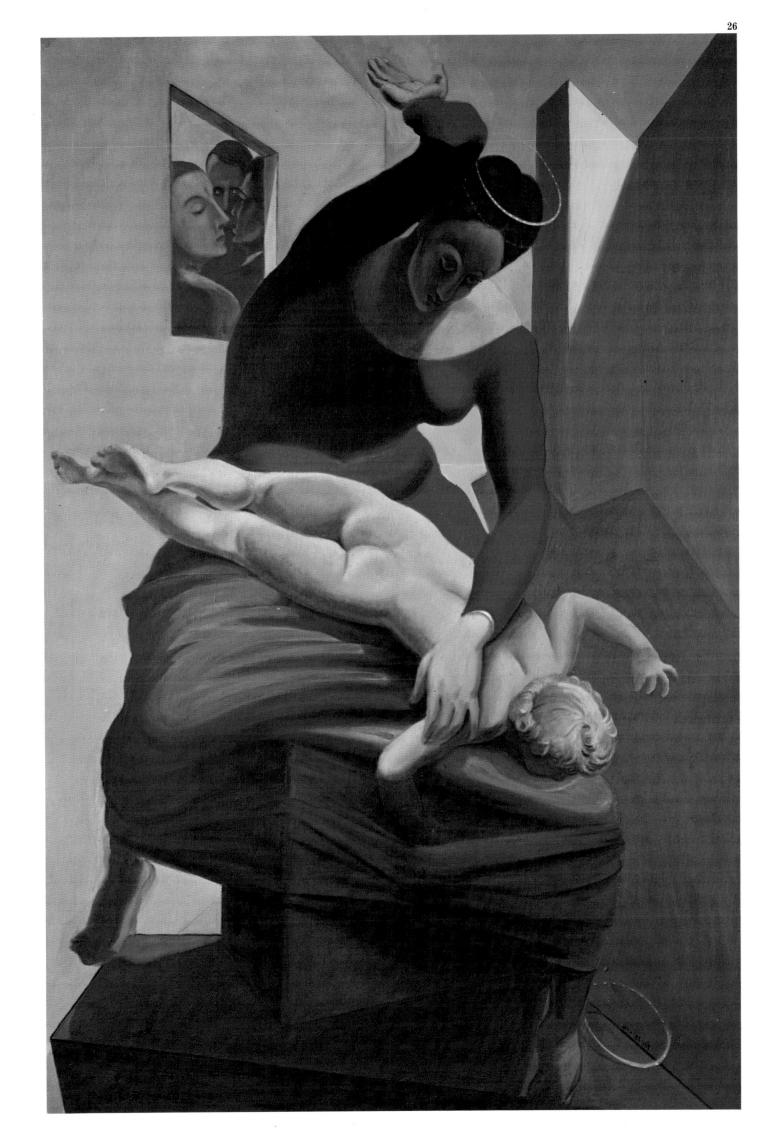

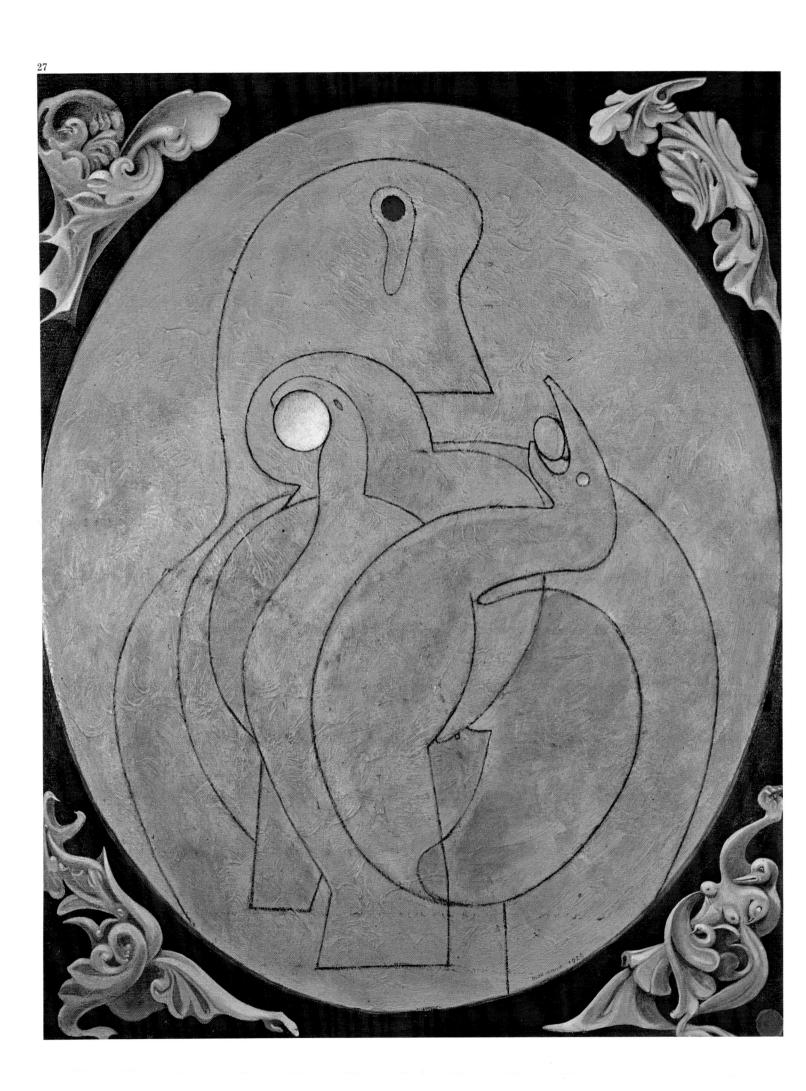

27 Inside the Sight: The Egg, *1929. Ernst presents here a radiographic view of the inside of the egg from which his alter ego, Loplop, would hatch. From a compositional standpoint, the image seems to be taken from a family photo album.*

28 Human Figure, *1931.* Human Figure *foreshadowed his production from the late thirties, namely those compositions that were entirely overrun by a luxuriant vegetation. Ernst creates here a hybrid figure, whose last remaining human vestiges are barely noticeable. Some scholars have interpreted this peculiar fusion of animal, vegetal, and human elements as an echo of Sigmund Freud's* Civilization and Its Discontents.

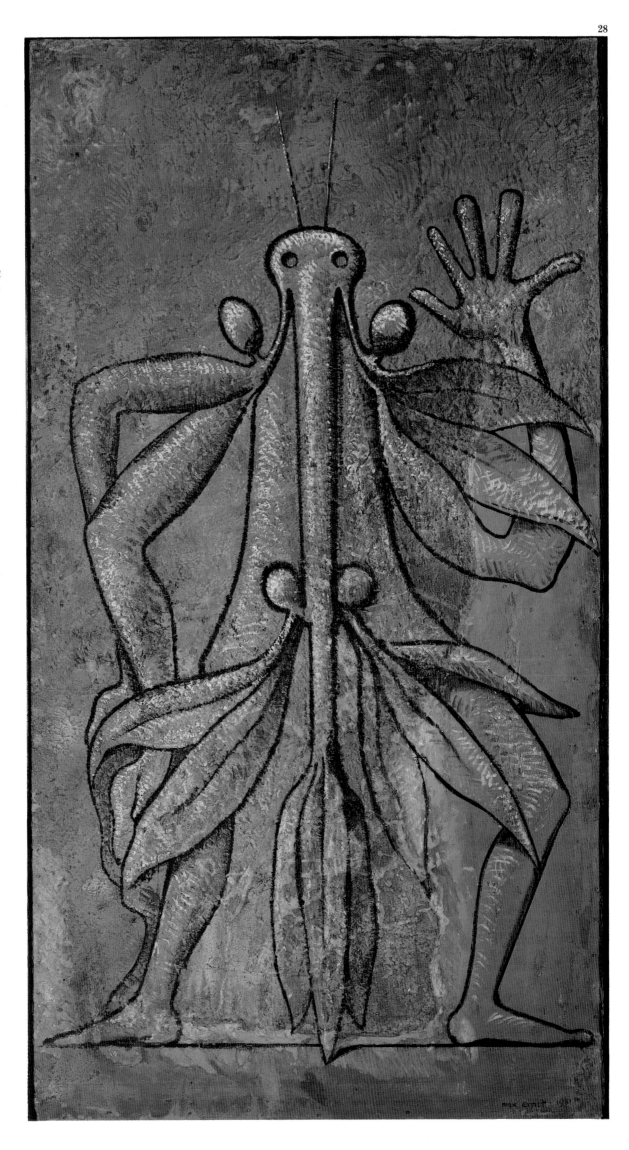

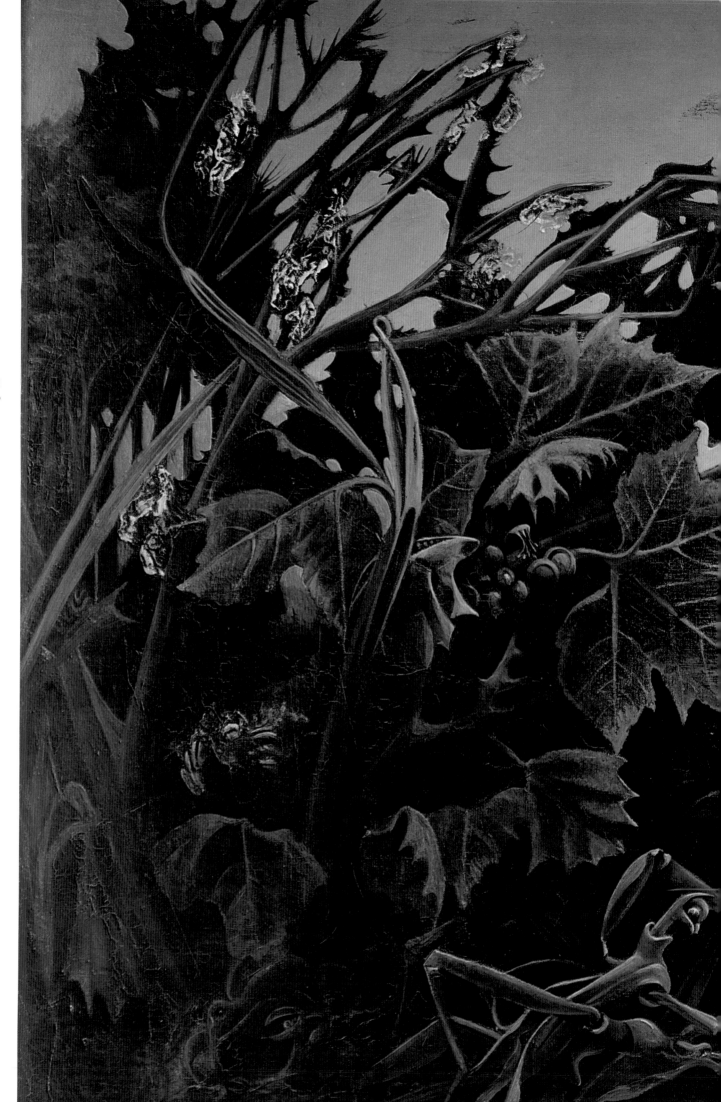

29 The Joy of Life, *1936. In 1936 Ernst created two similar works by the same title,* The Joy of Life, *in which a two-headed creature attempts to seize a fruit. In the present version, nature has all but obliterated the human element, as the strange being that is picking the fruit is in fact ominous and threatening, with the features of an abyssal fish. Only an enigmatic female figure manages to emerge from the oppressive vegetation: an otherworldly Hellenistic Venus taming a quaint-looking wild beast.*

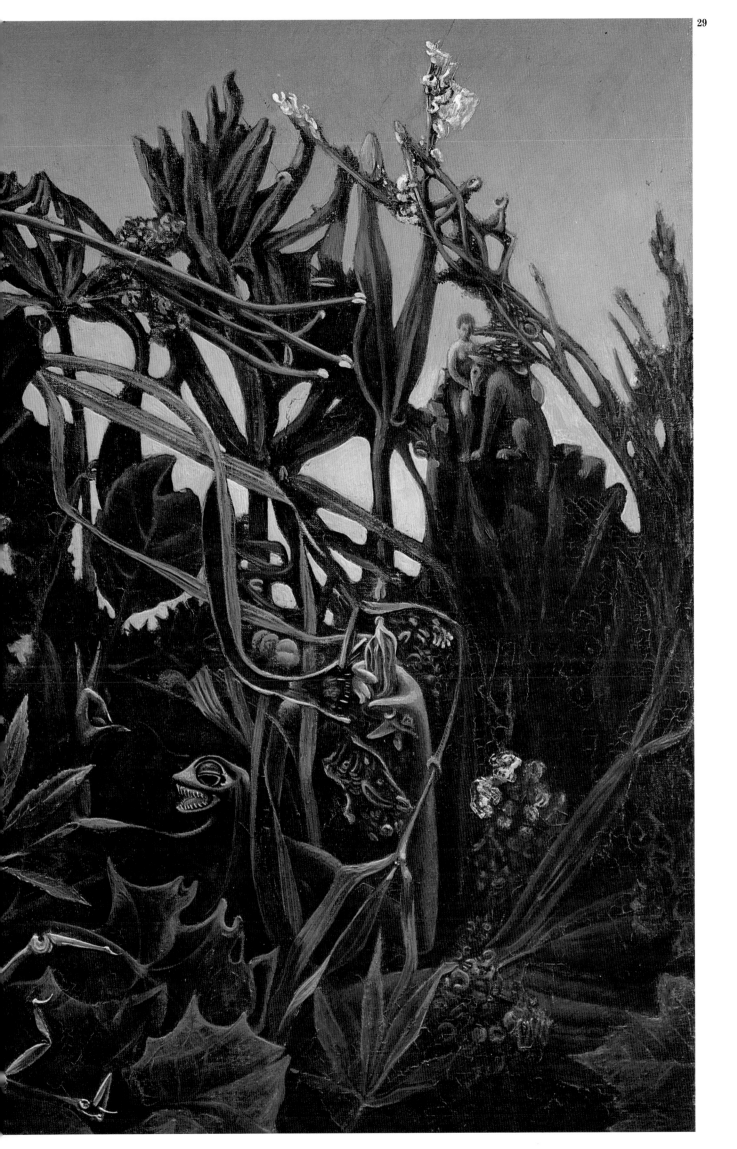

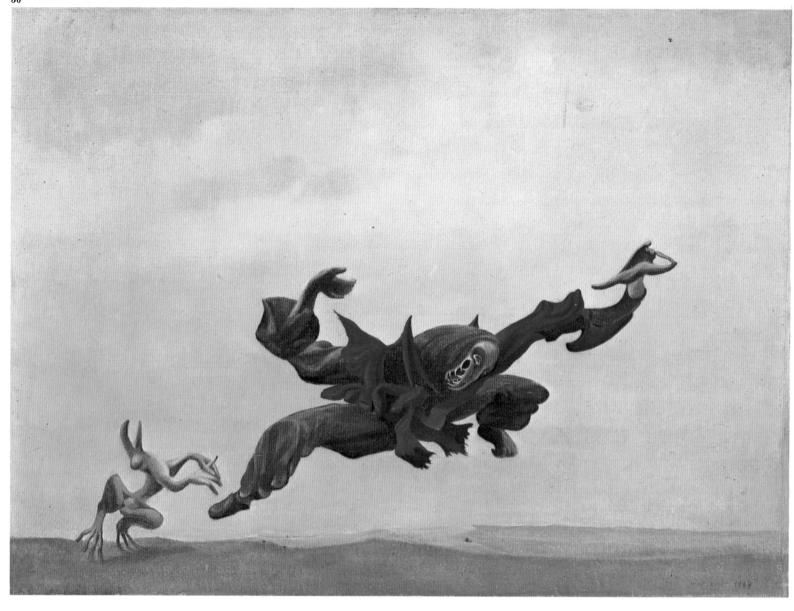

30 The Angel of Hearth and Home, *1937. With this work, Ernst expressed his denunciation of the Spanish Civil War. The terrible monster, which Loplop is unable to restrain, represents the threat of fascism that was rapidly spreading through Spain and would soon hold the rest of Europe in its grim clutch.*

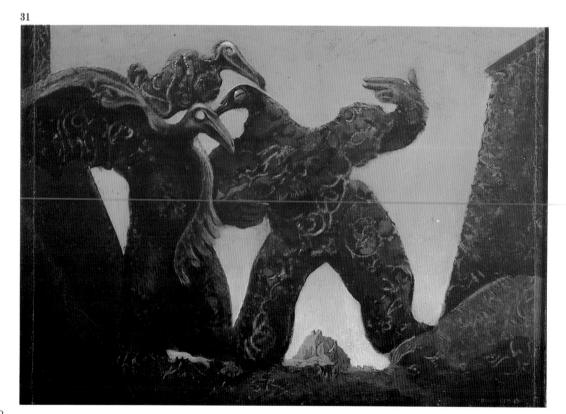

31 Barbarians Marching to the West, *1935. Somber figures of death threaten to obliterate everything. Ernst, who had already been a victim of Nazi persecution, foreshadows in this composition the abominable developments that would ravage Europe a mere five years later.*

32 The Robing of the Bride, *1939. The ritual preparation for the nuptials is disrupted by some disturbing elements which seem to imply that the ceremony is not quite legitimate. The threatening appearance of the armed figure and the sordid hermaphrodite in tears contrast with the richness of the bride's gown. The garment itself was apparently inspired by a description that Breton had made of a cloak "made up of the endless repetition of the tiny feathers of some bizarre bird, used by Hawaiian chieftains."*

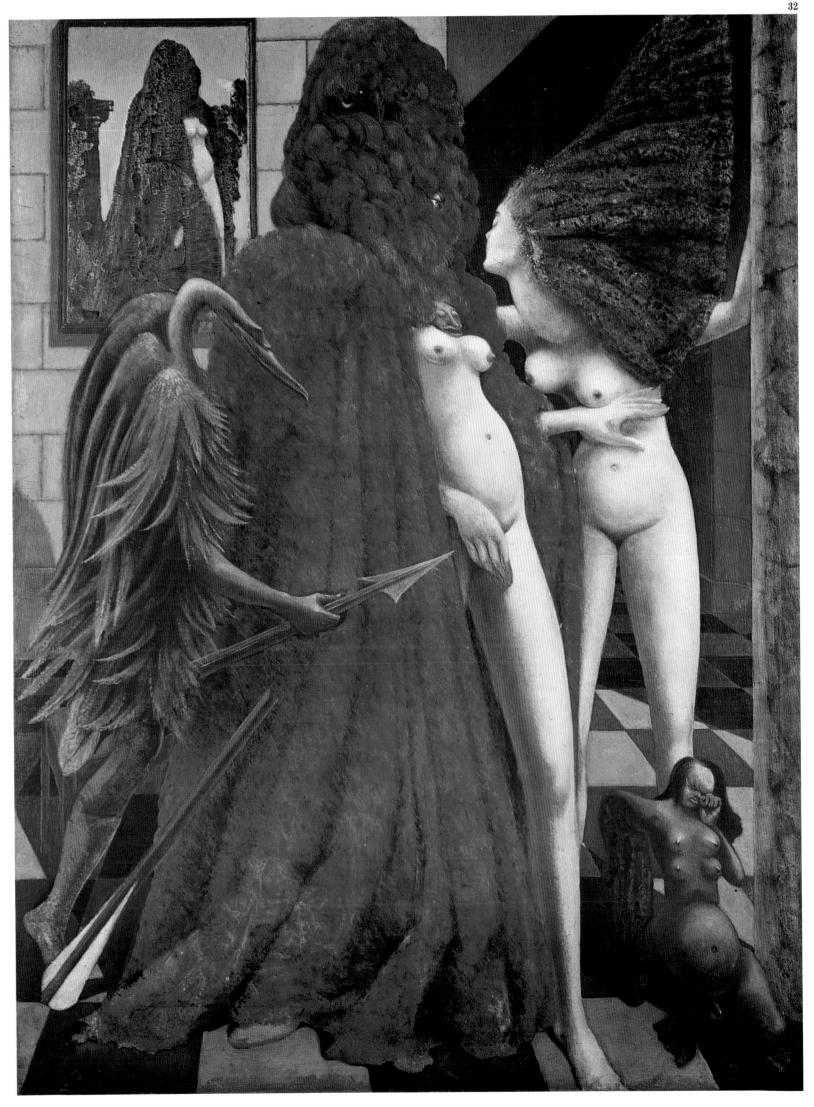

New Mediums for a New Aesthetic

In 1925, the quest for new expressive methods that would make the principles of automatic writing applicable to the visual arts yielded the technique of *frottage*. Ernst described his discovery in terms of a romantic vision: one stormy night, the painter stopped at an inn where, at once, he noticed the floor boards' tarnished surface. Mesmerized by this sight, which had summoned some childhood memory, he attempted to decipher its meaning by randomly dropping a few sheets of paper on the floor and rubbing a black pencil over them; the resulting images possessed an astonishing evocative power. Ernst would later correlate this newfound technique to a celebrated passage from Leonardo da Vinci's treatise *On Painting* in which the Renaissance genius urges artists to dwell on the stains on a wall and discover how strange features, landscapes, and even battle scenes will arise before their own eyes. The very nature of this method—which spawned such variations as *grattage* (from the French verb *gratter*, to scrape)—required that the painter renounce his claims to authorship and witness the birth of the work of art as an amazed spectator. As one critic pointed out, the artist no longer paints what he dreams, he dreams as he is painting.

33

33 Untitled, *1925. Fascinated by his discovery of* frottage, *Ernst experimented with the new medium on all sorts of surfaces. In general, the mechanism by which the artist obtained the images is dissimulated, sometimes to the extent of preventing the identification of the materials that he employed.*

34 Two Sisters, *1926. Gradually* frottage *went from being executed on paper to being integrated in oil paintings on canvas. The rough surface of the canvas itself then becomes the medium that, upon being rubbed with a pencil, yields unexpected images.*

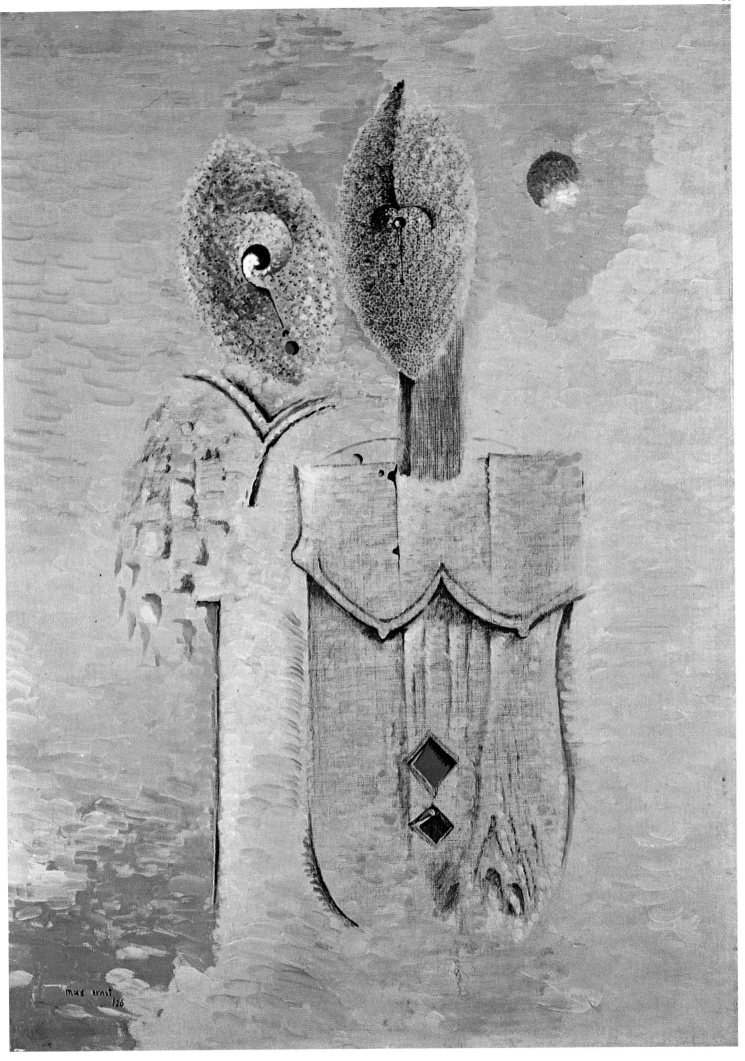

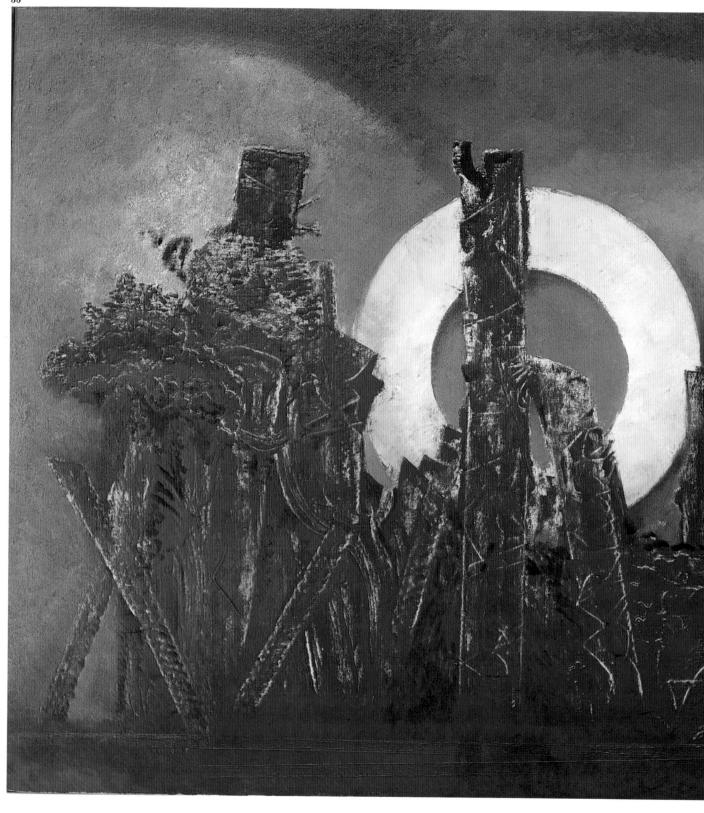

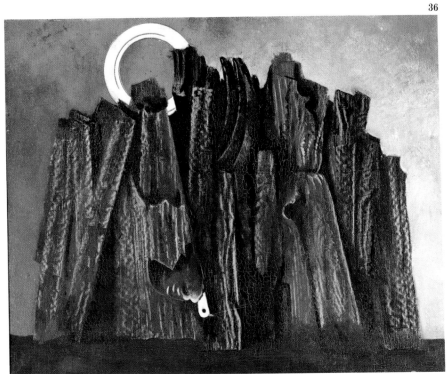

35, 36, 37 The Great Forest, *1927;* Shady Forest and Bird, *1926;* Forest, Bird, and the Sun, *1926. Ernst, whose discovery of* frottage *was associated with a childhood recollection, employed this technique to recreate the image of one of his earliest obsessions, namely the forest. Indeed his preoccupation with forests was such that it fills a considerable share of his autobiography with lines such as the following, "What is a forest? . . . It is the wonderful pleasure to be able to breathe freely in an open space but, at the same time, it is the anguish of being imprisoned, surrounded by hostile trees. . . . They are fierce and impenetrable, they are black, rusty and dun, they are dissolute, mundane . . . cruel, enthusiastic, and gentle, they have no yesterday nor tomorrow."*

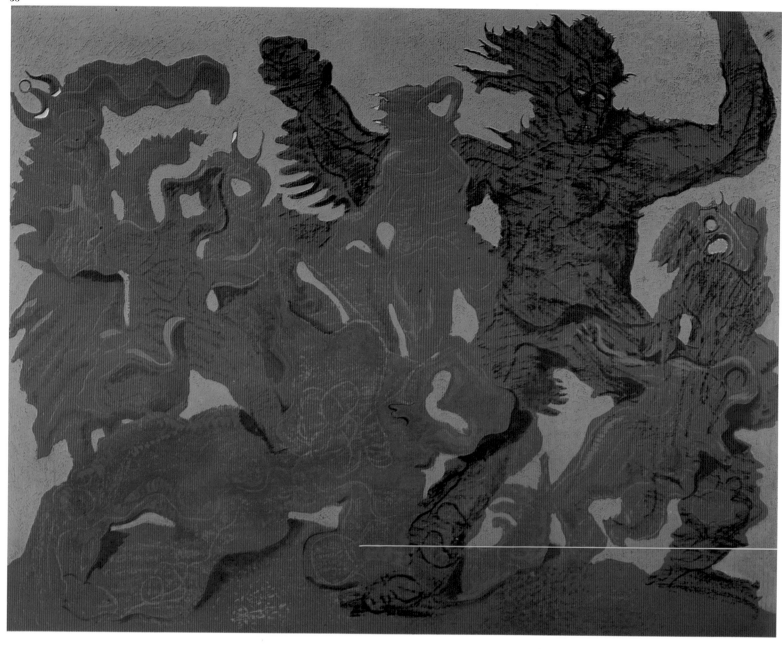

38, 40 The Horde, *1927; They Slept for Too Long in the Forest, 1927. These two paintings seem to depict consecutive scenes, which Ernst used to reveal the effect of too long a contact with those "fierce and impenetrable" woods: spectral beings, who partake of the trees' rustic quality, stretch out in the former, while in the latter they ominously advance against some unidentified antagonist.*

39 The Fragrant Forest, 1933. *Ernst painted this version of his trademark forest during his stay at a castle in Italy. According to an explanation provided by the artist himself, the title of this work is owed to some members of the household staff who, admiring the painter's creation, cried out "La foresta imbalsamata!" ("The fragrant forest!"), an allusion to a duet from the opera* Aida, *which they had seen a few days earlier.*

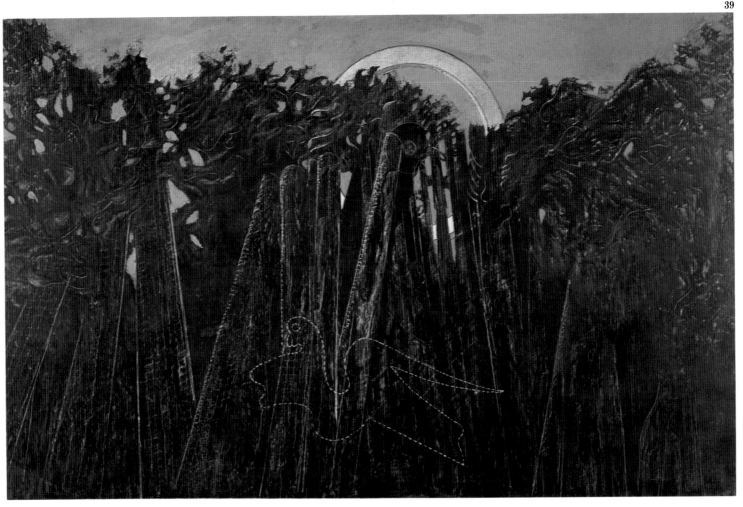

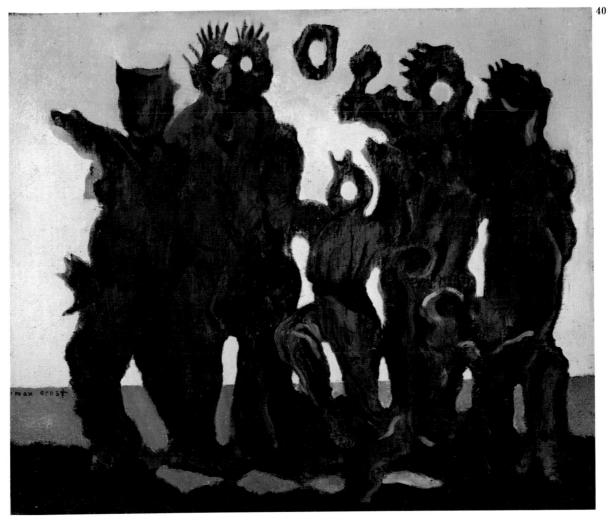

One Week of Goodness

Collage, as an artistic technique devised by the Cubists, originally consisted in pasting the most disparate materials on the pictorial surface so as to underscore the two-dimensional nature of the work of art, that is to say its condition as a physical object. During his Dadaist phase, Ernst frequently resorted to this medium to express his rejection of traditional artistic forms. Near the end of the 1920s, when he reclaimed the technique in a series of collage-novels, his goals were considerably more far-reaching. Works like *The Woman with 100 Heads* (1929) and *Dream of a Young Woman Wishing to Become a Carmelite* (1930) provide an unmistakable illustration of the Surrealist principle, according to which poetic images are engendered by the association of dissimilar elements. That explains why, unlike the Cubists, Ernst effaces from these works any trace of his intervention. The best example of this is quite possibly his collage-novel *One Week of Goodness, or The Seven Deadly Elements*, published in 1934. This work, an evocation of the Biblical creation of the world in one week, is based on the engravings of a nineteenth-century serial, Jules Mary's *Les damnés de Paris*, as well as on a number of images excerpted from old zoology textbooks.

41, 42 *Illustration for Jules Mary's* Les damnés de Paris, *1883; Collage from* One Week of Goodness, *1934. By introducing a few subtle alterations, Ernst successfully transforms a conventional romantic scene into an encounter fraught with erotic tension. In his version, the young woman's lost gaze is directed toward a new character, whose head is that of an Easter Island idol. The irruption of a third party confers an openly lewd quality on the original embrace.*

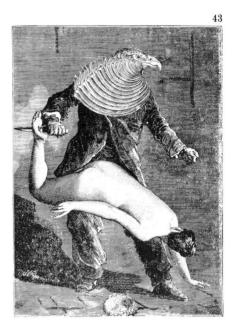

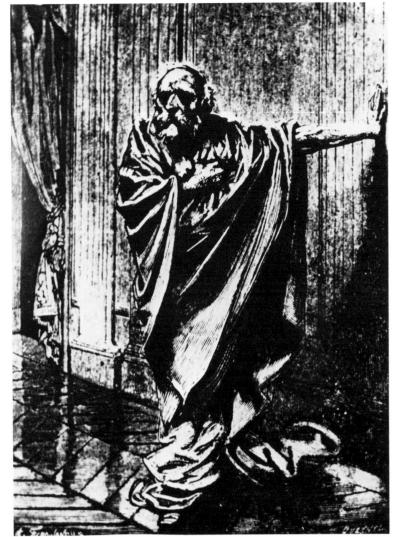

43 *Collage from* One Week of Goodness, *1934. The other title of this novel-by-images,* The Seven Deadly Elements, *clarifies the meaning of the story, which associates each day of the week with one deadly sin and one element. In the illustrations for Wednesday, the day of blood, a bandit with an eagle's head perpetrates all sorts of iniquities.*

44, 45 *Illustration for Jules Mary's* Les damnés de Paris, *1883; Collage from* One Week of Goodness, *1934. Once again, the original engraving makes it possible to analyze the creative process behind Ernst's collage. The solemnly dignified figure in a toga is transformed into a terrible being with a feline head that looks menacingly at a helpless young woman.*

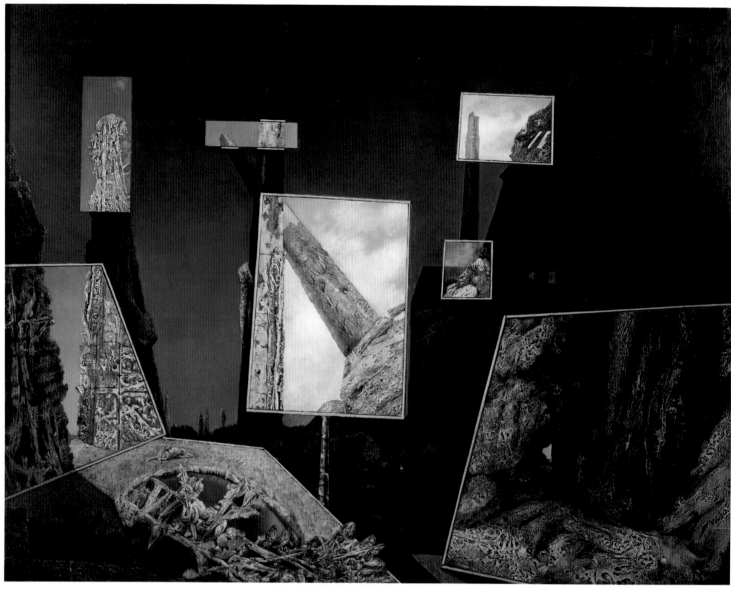

The Years of the American Exile

Like many artists whose works were branded as "degenerate" by the Nazi authorities, Ernst was forced to leave Europe as a result of the outbreak of World War II. During the first few years of his American period, the painter's production reflected the pessimism of his exile: landscapes devastated by violent cataclysms and stripped almost entirely of any trace of life. They are at the most, peopled by ghostly beings that partake of the landscape's lava-like quality. This disintegrating effect was obtained by means of *decalcomania*, a technique pioneered by the Surrealist painter Óscar Domínguez, which in its most basic form consists of spreading diluted black gouache over a sheet of white paper, laying a second sheet on top of it, and after applying a light pressure, peeling it off before the paint has had time to dry. Another one of Ernst's technical discoveries during this period was *dripping*, which involves the most radical application of the principle of automatism to the visual arts: the painter, standing above the canvas, holds a pierced can over it and lets paint trickle down, so that chance is the real author of the resulting work of art.

46 Day and Night, *1941–42. The artist himself once described this work in these terms: "Day and night, or the pleasures of painting: listening to the rhythm of the earth; surrendering to the fear that comets and the unknown inspire in mankind; expelling the sun at one's own discretion; lighting the spotlights of the mind's night; enjoying the cruelty of certain eyes; contemplating the sweet sparkle of a thunderbolt; the magnificence of trees; invoking the fireflies."*

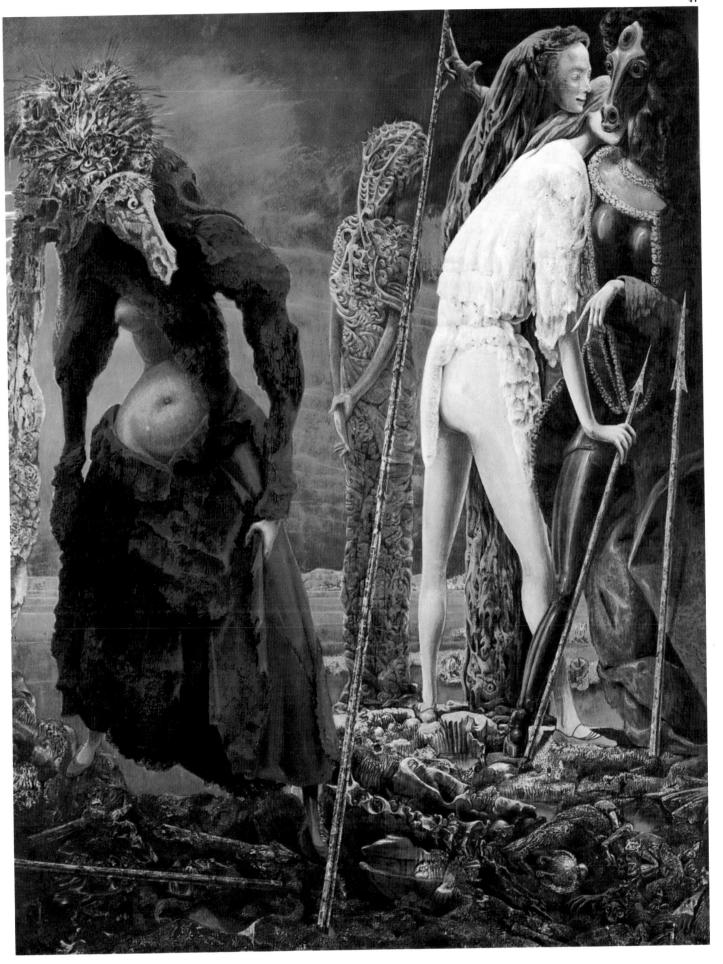

47 The Antipope, *1941–42. It is almost impossible to dissociate this work from the dynamics of death and destruction that dominated our civilization in those years. The two female figures—whose sensuality is in sharp contrast with the bed of decaying organic matter over which they are treading—appear to be fatally lured by some sinister creatures.*

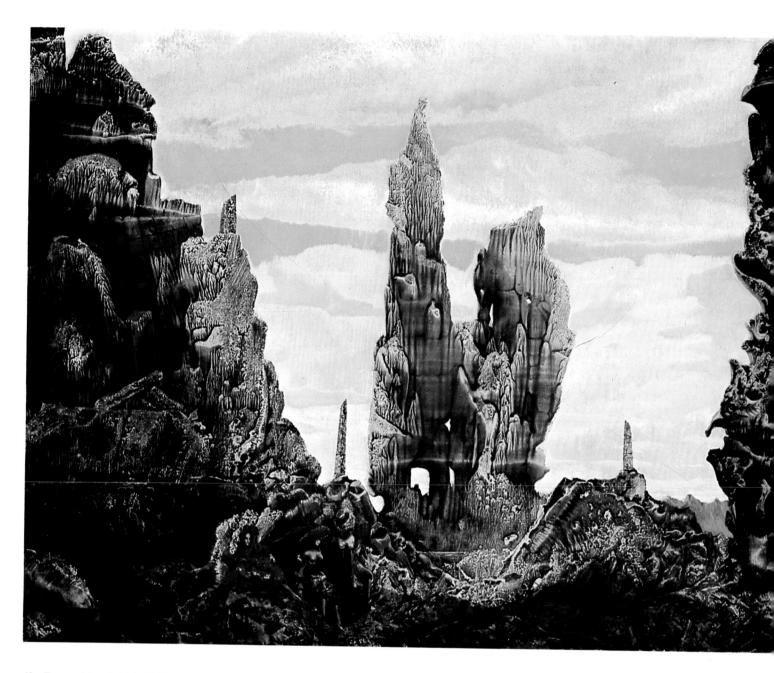

48 Europe After the Rain II, *1940–42. Ernst altered the original* decalcomania *technique so that he might be able to use it with oil paints. Instead of using paper, he would instead lay on the canvas a sheet of glass which, upon being retracted, would leave the distinctive texture of decaying matter. This method proved ideal for Ernst's prefiguration of the desolation and death that would descend over Europe at the conclusion of the war.*

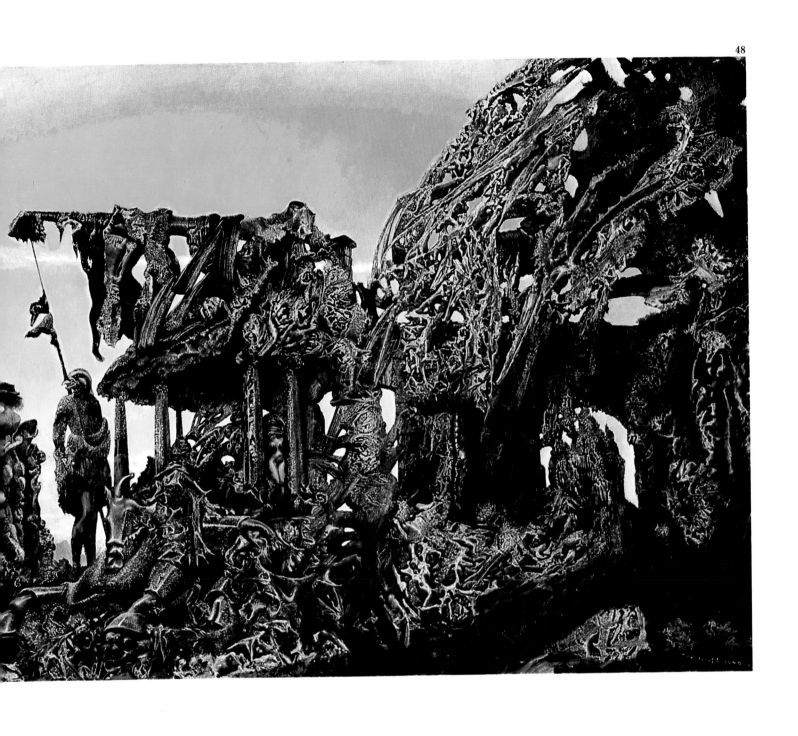

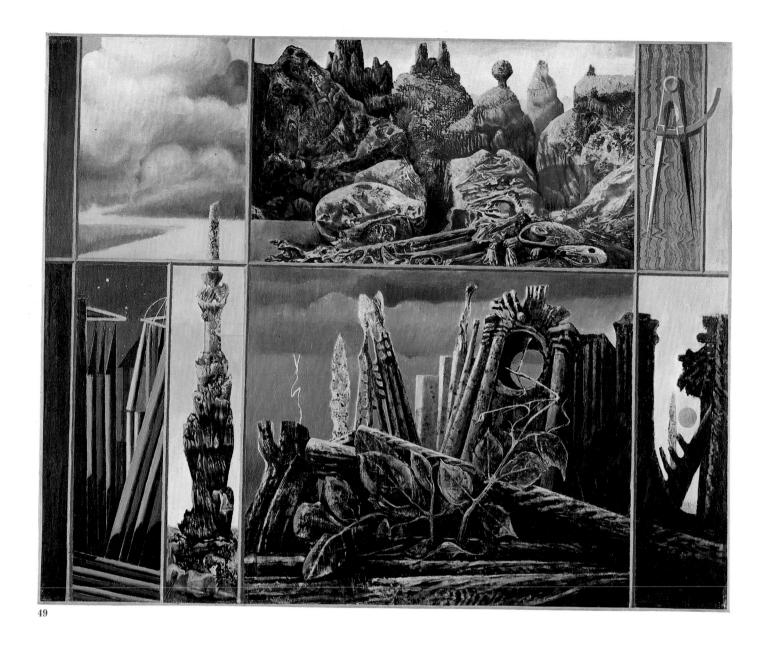

49

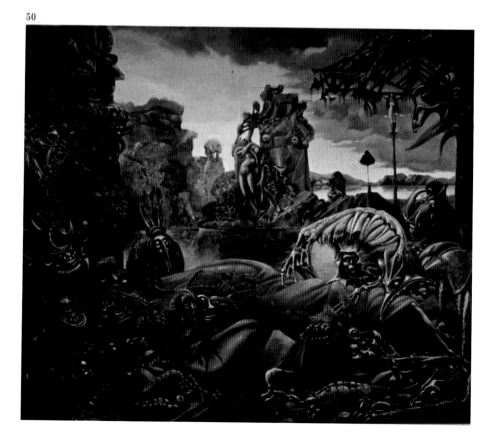

49 A Painting for the Young, *1943. Both the title and the compartment-like composition of this work bespeak its didactic nature. The various panels constitute a sort of summary illustrating the different techniques, from collage to* decalcomania, *that Ernst employed in the course of his career.*

50, 51 The Temptations of St. Anthony, *1945. According to the Christian tradition, St. Anthony was beset during his ascetic retreat by two distinct sources of dangers: the demons who ripped his body and a series of lewd visions. Ernst pushed the erotic aspect to the background and gave emphasis instead to his portrayal of the monstrous beings, whose vivid depiction evokes the influence that the works by the late-Gothic German painter Matthias Grünewald had on Ernst's production.*

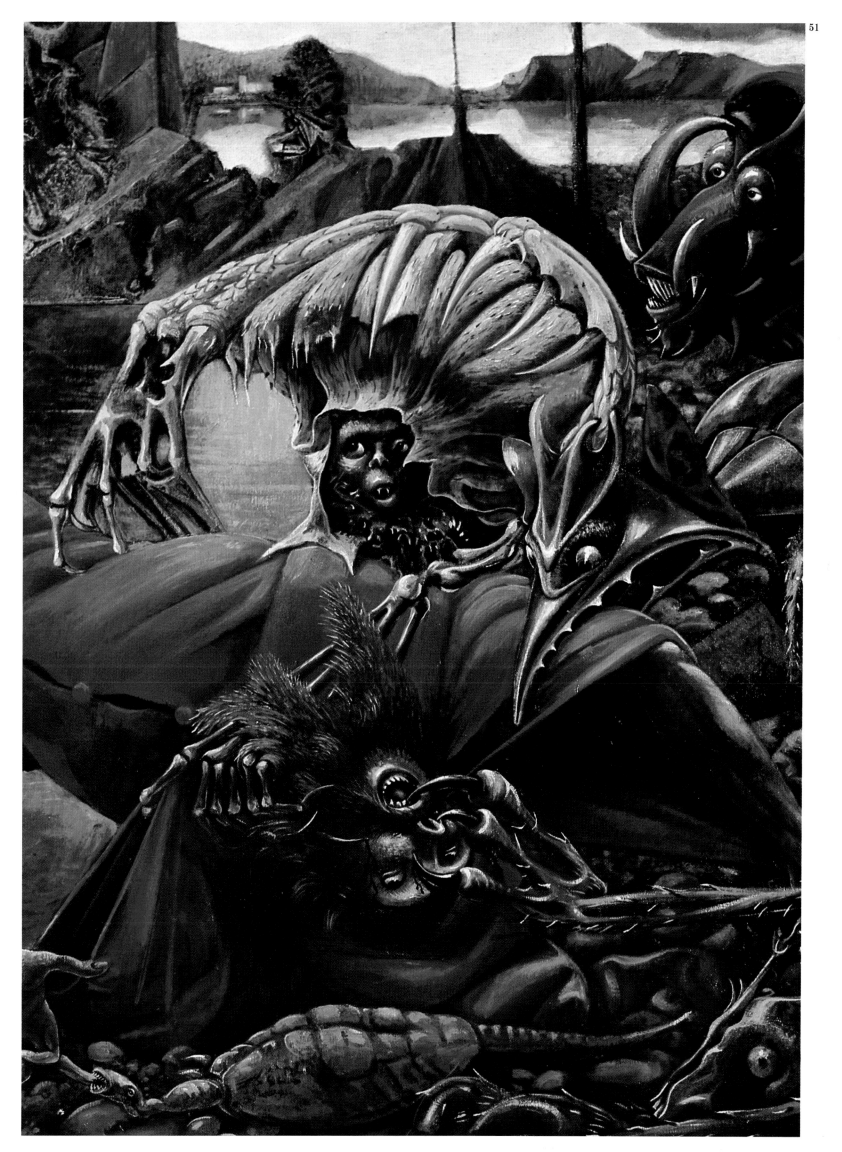

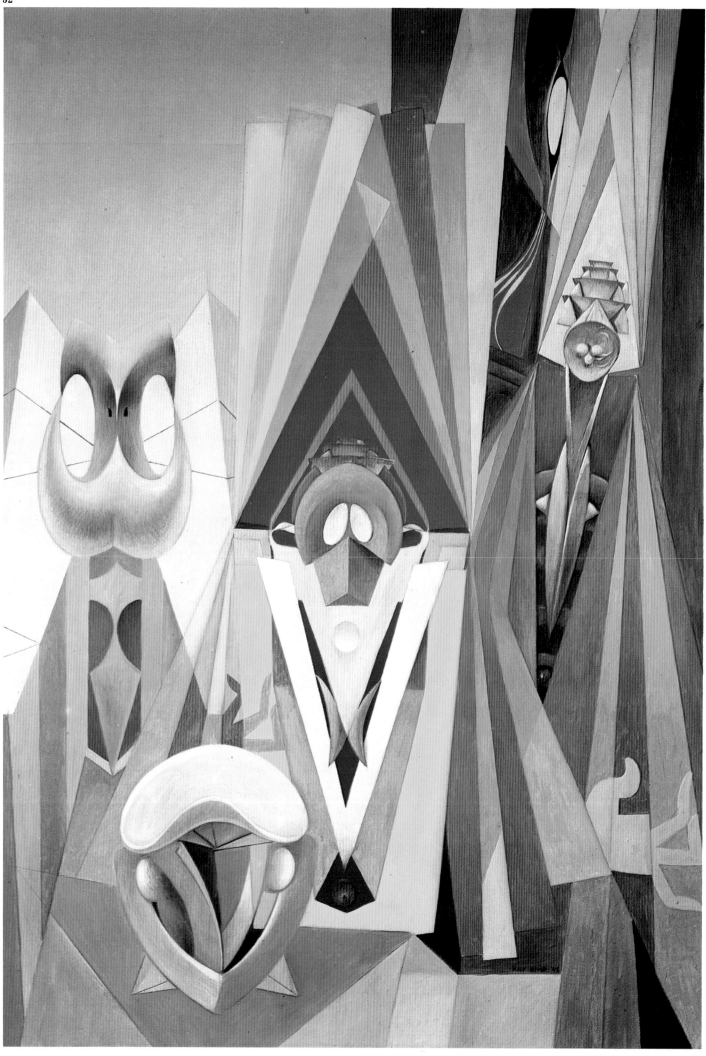

52 The Feast of the Gods, *1948. In the mid-1940s, Ernst's work underwent a radical change. The organic exuberance of his earlier production gave way to an entirely unexpected geometric order, rendered in a vibrant palette that effectively replaced his formerly somber tonalities.*

53, 54 The Bewildered Planet, *1942;* Young Man Intrigued by the Flight of a Non-Euclidean Fly, *1942–47. The foremost contribution from this phase of the artist's career is his invention of the* dripping *technique, which allowed Ernst to carry through the dismissal of traditional painterly methods which he had undertaken twenty-five years earlier. The significance of* dripping *resides not so much in the rather scarce use that Ernst made of his latest discovery as in the enormous influence that it exerted on an entire generation of post-war American painters.*

54

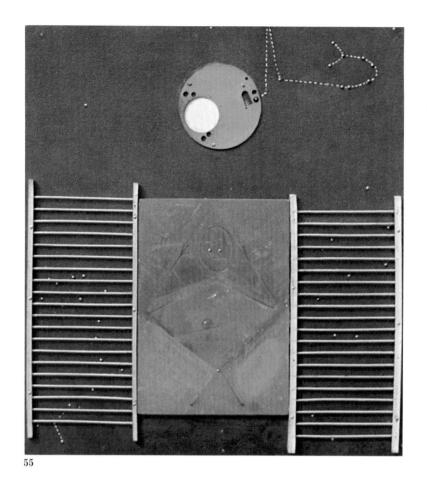

55

55, 56 The Great Ignoramus, *1965;* First Thought, *1965. Ernst often used fragments of birdcages in the collages that he produced in the mid-1960s: a confirmation and a reminder of the profound fascination with the realm of birds that the artist felt throughout his life.*

56

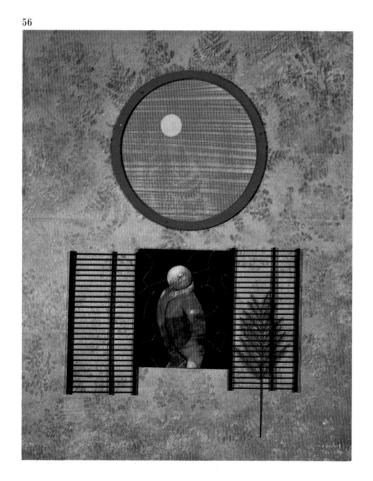

Back to the Origins

The course of Ernst's artistic career followed a rather unusual circular trajectory. Upon returning to Europe after the war, he reclaimed some of the elements that had characterized his production in the 1920s. The collage technique, in particular, would again play a central role. The new compositions put together with disparate objects and materials which, albeit reminiscent of Ernst's own Dadaist phase, have gained simplicity and evince the artist's decorative intent in a way that was entirely lacking in his youthful production. A gentle irony, especially in his choice of titles, permeates Ernst's late works, in which visual references have all but disappeared and the use of cheerful, bright tonalities testifies to the fact that the artist was enjoying his painterly métier more than ever before.

57, 58, 59, 60 Commonplaces: *Frontispiece;* Everyday Life; The Maidens, Death, and the Devil; Where to Get Going, *1971.* Commonplaces *is an album of twelve collages accompanied by eleven poems. In addition to the use of color, another striking contrast is also quite evident between this work and its predecessor,* One Week of Goodness: *unlike the wealth of themes and the tumultuous intensity of the earlier series,* Commonplaces *is characterized by the static quality of its images and by the virtually complete lack of living elements.*

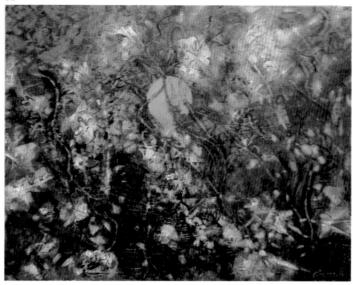

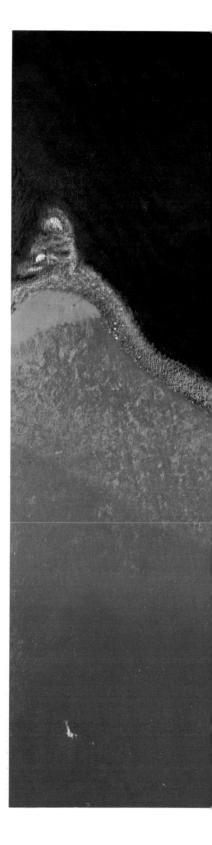

61, 62 The Last Forest (On Tuesdays the Moon Is All Decked Out),
first version; The Last Forest, *1960–69. During the last phase of
his career, Ernst returned to explore the theme of the forest. The
ring of the moon, familiar in his compositions from the 1920s, is
once again present, while the formerly somber dryness of the trees
has now given way to a thick, luxuriant vegetation that is rather
reminiscent of the jungles that he painted during the 1930s, albeit
devoid of their threatening quality.*

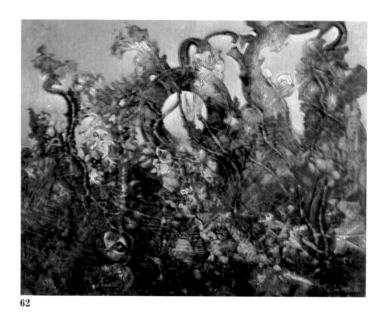

62

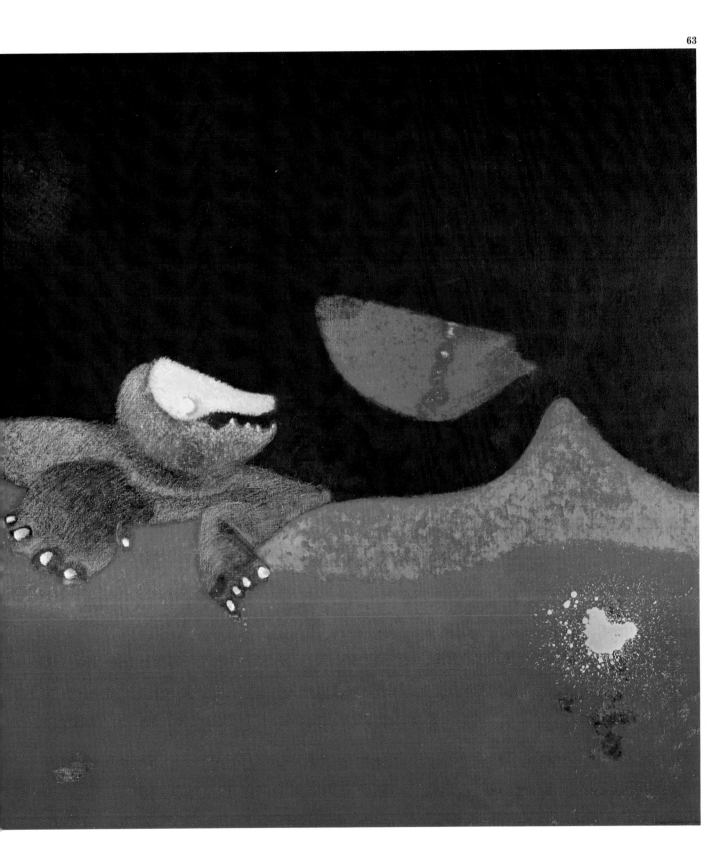

63 Banner for a School of Monsters, *1968. A comparison of this friendly monster with the terrible figures that swarm* The Joy of Living *(see pl. 29) or those that rip through St. Anthony's body (see pls. 50, 51) readily yields the conclusion that, in his maturity, Ernst must have tired of apocalyptic excesses and gained a more amiable existential posture.*

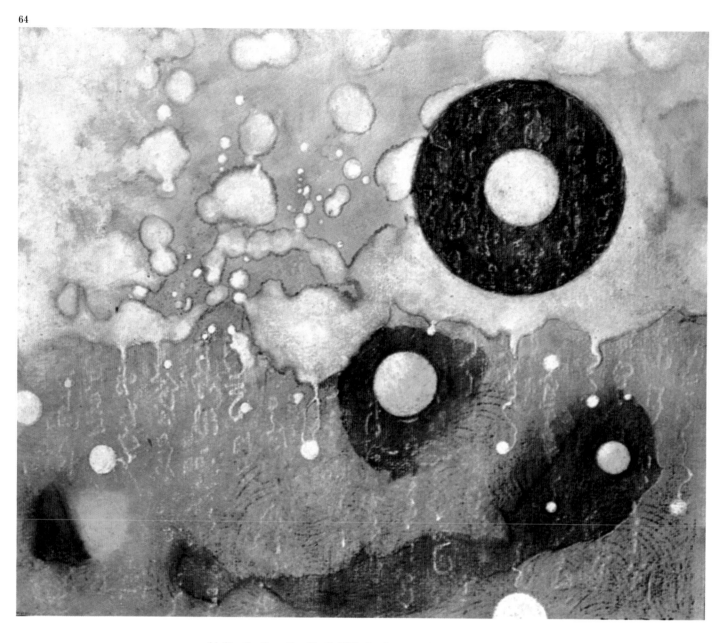

64, 65 Configuration No. 6, *1974;* Configuration No. 16, *1974.*
Ernst's last works constitute a genuine reversion to the origins of
his own career. Half a century later, the artist appears to be still
affected by the same eager inquisitiveness that had first led him
through the discovery of the expressive opportunities afforded by
frottage *and* dripping. In the Configuration *series, those same*
techniques are shown in their unadulterated essence, that is to
say, without any claim to be suggestive of any other reality than
that of the painted surface.

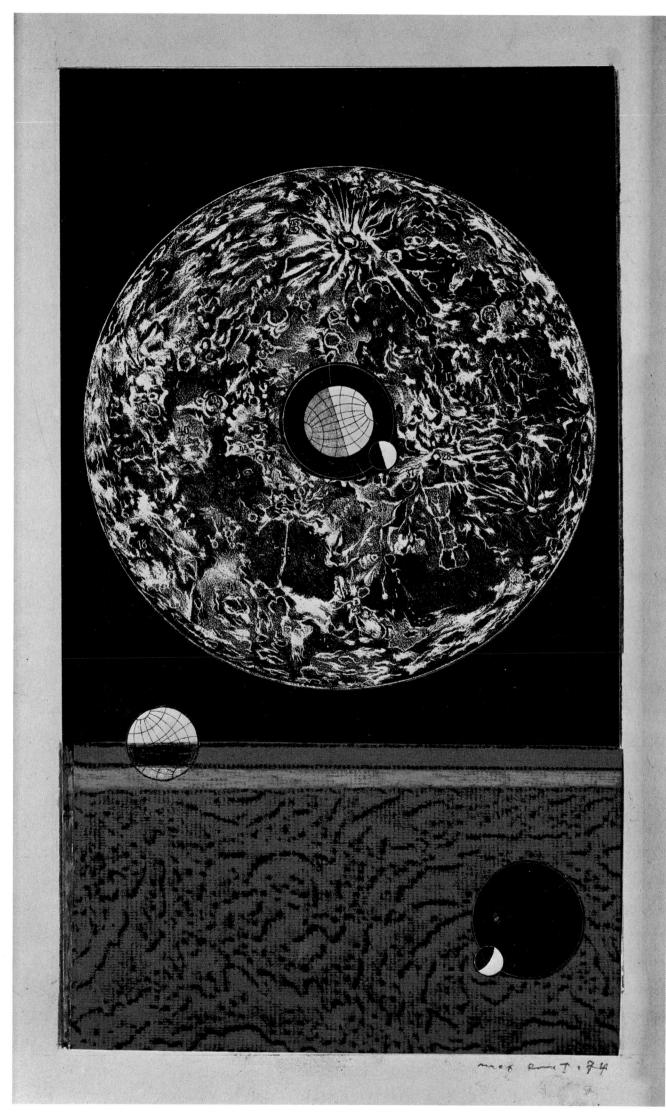

List of Plates

1 Fish Fight, *1917. Watercolor on paper, 5½ × 8⅛" (14 × 20.5 cm). Private collection*

2 Landscape with Sun, *1909. Oil on paperboard, 7⅛ × 5⅜" (18.1 × 13.7 cm). Private collection*

3 Immortality, *1913–14. Oil on wood, 18⅛ × 12¼" (46 × 31 cm). Fukuoka City Bank, Fukuoka*

4 Crucifixion, *1913. Oil on paper, 20⅛ × 16⅞" (51 × 43 cm). Wallraf-Richartz Museum, Cologne*

5 Hostess on the Lahn, *1920. Collage with gouache, and watercolor on paper mounted on paperboard, 9⅞ × 12⅝" (25 × 32.1 cm). Staatsgalerie, Stuttgart*

6 Fruit of a Long Experience, *1919. Relief of wood, wire, and painted metal, 18⅛ × 15" (46 × 38 cm). Private collection, Switzerland*

7 Aquis Submersus, *1919. Oil on canvas, 21¼ × 17¼" (54 × 43.8 cm). Stadelsches Kunstitut, Frankfurt*

8 The Great Orthochromatic Wheel Making Customized Love, *1919–20. Watercolor and pencil on printed leaves, 13¾ × 8⅞" (35.5 × 22.5 cm). Musée National d'Art Moderne, Centre Georges Pompidou, Paris. Donated by Louise and Michel Leiris, 1984*

9 The Flamingos, *1920. Collage with photographs and India ink on paper mounted on paperboard (Fatagaga), 6⅛ × 5⅛" (15.5 × 13 cm). Private collection, Paris*

10 Self-Portrait, *1920. Collage, photograph, and gouache on paper (Fatagaga) 7 × 4½" (17.8 × 11.5 cm). The Arnold H. Crane Collection, Chicago*

11 The Master's Bedroom It's Worth Spending a Night There, *1919. Collage with gouache and pencil on paper, 6½ × 8¾" (16.5 × 22.2 cm). Private collection*

12 Dada-Degas, *c. 1920. Collage and gouache on paper, 18⅞ × 12¼" (48 × 31 cm). Bayerische Staatsgemäldesammlungen, Staatsgalerie moderner Kunst, Munich. Foundation Theo Wormland*

13 Oedipus Rex, *1922. Oil on canvas, 35 × 45¾" (88.9 × 116.2 cm). Private collection*

14 The Pleiades, *1920. Collage of photographs, gouache, and oil on paper, 8⅞ × 6½" (22.5 × 16.5 cm). Private collection*

15 Celebes the Elephant, *1921. Oil on canvas, 49¼ × 42⅛" (125 × 107 cm). Tate Gallery, London*

16 Ubu Imperator, *1924. Oil on canvas, 31⅞ × 25⅝" (81 × 65 cm). Musée National d'Art Moderne, Centre Georges Pompidou, Paris. Donated by the Foundation for Medical Research in honor of Mrs. Hélène Anavi, 1984*

17 Pietà, or The Revolution by Night, *1923. Oil on canvas, 45⅝ × 35" (115.9 × 88.9 cm). Tate Gallery, London*

18 Untitled, *1923. Door from the home of Paul Eluard in Eaubonne (France). Oil on panel, 80¾ × 31½" (205 × 80 cm). Sprengel Museum, Hannover*

19 The Equivocal Woman, *1923. Oil on canvas, 51⅜ × 38⅜" (130.5 × 97.5 cm). Kunstsammlung Nordrhein-Westfalen, Dusseldorf*

20 The Couple, *1923. Oil on canvas, 41½ × 56" (105.5 × 142.2 cm). Museum Boymans-van Beuningen, Rotterdam*

21 St. Cecilia (The Invisible Piano), *1923. Oil on canvas, 39¾ × 32¼" (101 × 82 cm). Staatsgalerie, Stuttgart*

22 At the First Clear Word, *1923. Fresco from the home of Paul Eluard in Eaubonne (France), transferred onto canvas, 91⅜ × 65¾" (232.1 × 167 cm). Kunstsammlung Nordrhein-Westfalen, Dusseldorf*

23 M Portrait, or The Letter, *1924. Oil on canvas, 32⅝ × 24⅜" (83 × 62 cm). Private collection, Switzerland*

24 Two Children Are Threatened by a Nightingale, *1924. Oil on wood with wood elements, 27½ × 22½ × 4½" (69.9 × 57 × 11.4 cm). The Museum of Modern Art, New York. Acquired, 1937*

25 Loplop Introduces a Young Girl, *1931. Oil and sundry materials on panel (version 3/3), 76¾ × 35" (195 × 89 cm). Private collection*

26 The Blessed Virgin Chastises the Infant Jesus before Three Witnesses: A. B. (André Breton), P. E. (Paul Eluard) and the Artist, *1926. Oil on canvas, 77¼ × 51¼" (196.2 × 130.2 cm). Museum Ludwig, Cologne*

27 Inside the Sight: The Egg, *1929. Oil on canvas, 38¾ × 31¼" (98.5 × 79.4 cm). The Menil Collection, Houston*

28 Human Figure, *1931. Oil and plaster on panel, 72 × 39⅜" (183 × 100 cm). Moderna Museet, Stockholm*

29 The Joy of Life, *1936. Oil on canvas, 28¾ × 36¼" (73 × 92 cm). Private collection, England*

30 The Angel of Hearth and Home, *1937. Oil on canvas, 21¼ × 29⅛" (54 × 74 cm). Bayerische Staatsgemäldesammlungen, Staatsgalerie moderner Kunst, Munich. Foundation Theo Wormland*

31 Barbarians Marching to the West, *1935. Oil on paper mounted on paperboard, 9½ × 13″ (24 × 33 cm). Private collection*

32 The Robing of the Bride, *1939. Oil on canvas, 51⅛ × 37¾″ (130 × 96 cm). Peggy Guggenheim Collection, Venice*

33 Untitled, *1925.* Frottage *with pencil on paper, 17 × 10⅛″ (43.2 × 25.8 cm). Private collection, Paris*

34 Two Sisters, *1926. Oil and black lead* frottage *on canvas, 39½ × 28¾″ (100.3 × 73 cm). The Menil Collection, Houston*

35 The Great Forest, *1927. Oil on canvas, 45⅛ × 57⅝″ (114.5 × 146.5 cm). Kunstmuseum, Basel*

36 Shady Forest and Bird, *1926. Oil on canvas, 25¾ × 32⅛″ (65.5 × 81.5 cm). Private collection*

37 Forest, Bird, and the Sun, *1926. Oil on paper glued to paperboard, 25½ × 19⅝″ (64.6 × 50 cm). Private collection*

38 The Horde, *1927. Oil on canvas, 45¼ × 57½″ (114.9 × 146.1 cm). Stedelijk Museum, Amsterdam*

39 The Fragrant Forest, *1933. Oil on canvas, 64 × 100″ (162.6 × 254 cm). Private collection, New York*

40 They Slept for Too Long in the Forest, *1927. Oil on canvas, 18⅛ × 21⅝″ (46 × 55 cm). Private collection, Paris*

41 *Illustration for Jules Mary's* Les damnés de Paris, *1883. (Paris: J. Rouff)*

42 *Collage from* One Week of Goodness, *1934. (Editions Jeanne Bucher)*

43 *Collage from* The Week of Goodness, *1934. (Editions Jeanne Bucher)*

44 *Illustration for Jules Mary's* Les damnés de Paris, *1883. (Paris: J. Rouff)*

45 *Collage from* One Week of Goodness, *1934. (Editions Jeanne Bucher)*

46 Day and Night, *1941–42. Oil on canvas, 44⅛ × 57½″ (112 × 146 cm). The Menil Collection, Houston*

47 The Antipope, *1941–42. Oil on canvas, 63 × 50″ (160 × 127 cm). Peggy Guggenheim Collection, Venice*

48 Europe After the Rain II, *1940–42. Oil on canvas, 21⅝ × 58¼″ (54.9 × 148 cm). Wadsworth Atheneum, Hartford. The Ella Gallup Sumner and Mary Catlin Sumner Collection*

49 A Painting for the Young, *1943. Oil on canvas, 24 × 29⅞″ (61 × 76 cm). Collection Ulla and Heiner Pietzch*

50 The Temptations of St. Anthony, *1945. Oil on canvas, 42½ × 50⅜″ (108 × 128 cm). Wilhelm-Lehmbruck Museum der Stadt, Duisburg*

51 The Temptations of St. Anthony, *1945. Detail*

52 The Feast of the Gods, *1948. Oil on canvas, 60¼ × 42⅛″ (153 × 107 cm). Museum moderner Kunst, Vienna*

53 The Bewildered Planet, *1942. Oil on canvas, 46⅞ × 55⅛″ (119 × 140 cm). The Tel Aviv Museum of Art*

54 Young Man Intrigued by the Flight of a Non-Euclidean Fly, *1942–47. Oil and varnish on canvas, 32¼ × 26″ (82 × 66 cm). Private collection*

55 The Great Ignoramus, *1965. Oil and collage on panel, 45⅝ × 39⅜″ (116 × 100 cm). Private collection*

56 First Thought, *1965. Oil and collage on canvas, 39⅜ × 31½″ (100 × 80 cm). Private collection*

57 Commonplaces: *Frontispiece, 1971. (Paris: Editions Iolas)*

58 Commonplaces: Everyday Life, *1971. (Paris: Editions Iolas)*

59 Commonplaces: The Maidens, Death, and the Devil, *1971. (Paris: Editions Iolas)*

60 Commonplaces: Where to Get Going, *1971. (Paris: Editions Iolas)*

61 The Last Forest (On Tuesdays the Moon Is All Decked Out), *first version. Oil on canvas, 44⅞ × 57½″ (114 × 146 cm)*

62 The Last Forest, *1960–69. Oil on canvas, 44⅞ × 57½″ (114 × 146 cm). Musée National d'Art Moderne, Centre Georges Pompidou, Paris*

63 Banner for a School of Monsters, *1968. Oil on canvas, 34⅝ × 45¼″ (88 × 115 cm). Private collection*

64 Configuration No. 6, *1974. Oil on canvas, 21¼ × 25⅜″ (54 × 64.5 cm). Galerie Jan Krugier, Geneva*

65 Configuration No. 16, *1974. Collage,* frottage *and pencil on paper, 11 × 6½″ (28 × 16.5 cm). Private collection, Barcelona*

Series Coordinator, English-language edition: Ellen Rosefsky Cohen
Editor, English-language edition: Monica Mehta
Designer, English-language edition: Judith Michael

Page 1 Bird, *1942. Pencil on paper, 23⅝ × 18⅛″ (60 × 46 cm). Private collection*

Library of Congress Catalog Card Number: 97–70936
ISBN 0–8109–4696–3

Printed and bound in Spain by Filabo, S.A.
Sant Joan Despí (Barcelona)
Dep. Leg.: B. 15.352 – 1997